THE
QUEEN
OF
WANDS

The Story of Pamela Colman Smith, the Artist Behind the Rider-Waite Tarot Deck

CAT WILLETT

RUNNING PRESS

PHILADELPHIA

FOR EMIL AND JONI,
MY BELIEVERS.

Running Press
Hachette Book Group
1290 Avenue of the Americas, New York, NY 10104
www.runningpress.com
@Running_Press

Printed in China
First Edition: September 2022

Published by Running Press, an imprint of Perseus Books, LLC,
a subsidiary of Hachette Book Group, Inc. The Running Press name
and logo is a trademark of the Hachette Book Group.

The Hachette Speakers Bureau provides a wide range of authors for speaking events.
To find out more, go to www.hachettespeakersbureau.com or call (866) 376-6591.

The publisher is not responsible for websites (or their content) that are not
owned by the publisher.

Print book cover and interior design by Amanda Richmond.

Library of Congress Control Number: 2022931745

ISBNs: 978-0-7624-7569-8 (hardcover), 978-0-7624-7568-1 (ebook)

RRD-S

10 9 8 7 6 5 4 3 2 1

CONTENTS

"WHEN I TAKE A BRUSH IN HAND AND THE MUSIC BEGINS, IT IS LIKE UNLOCKING THE DOOR TO A BEAUTIFUL COUNTRY...

WITH PLAINS, MOUNTAINS, AND THE BILLOWING SEA"

P.C.S.

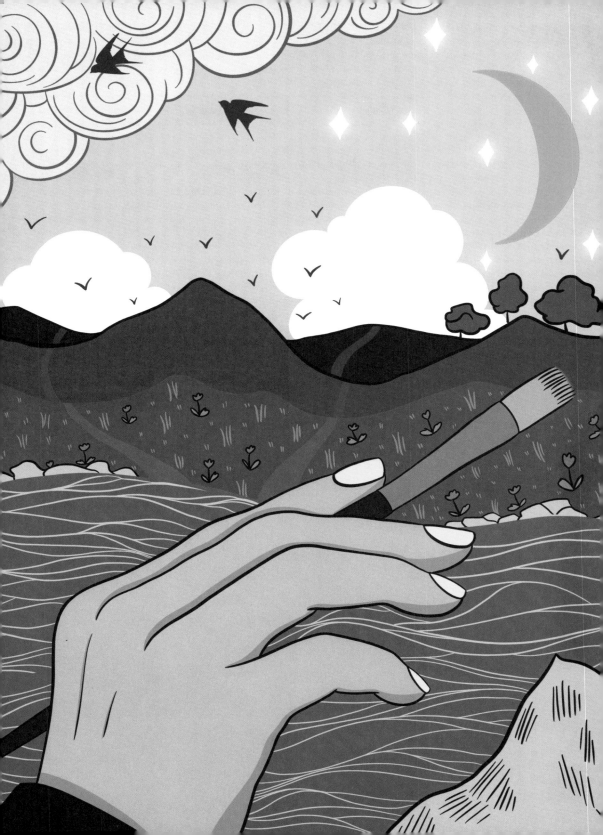

When I moved to New York and was struggling to navigate my new life in the city . . .

CATLAND
BOOKS

TAROT READINGS

BOOK NOW

I booked my first tarot reading.

R Brooklyn Bound

I was hoping to find some clarity and connect with something deeper than myself.

I wasn't really sure what to expect from the reading.

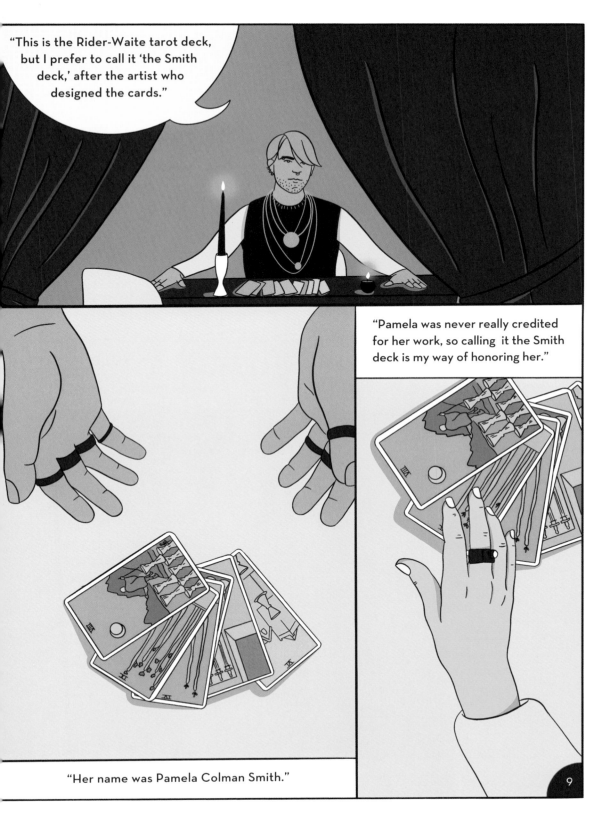

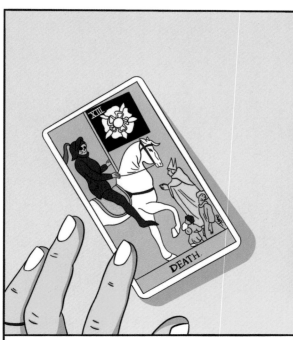

The reading was profound, and I still recall it clearly.

In general, I feel ambivalent about the occult, but I'm sure of the deep connection that my reader felt with the symbolism of the cards. . .

and of his efforts to pass that meaning on to me.

Years later, when I was looking for a research topic for graduate school. . .

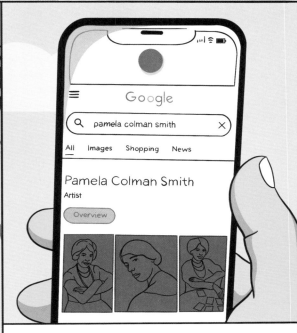

I vaguely recalled Pamela's name and looked her up online.

At the time my search yielded only one sparse Wikipedia page.

I felt an instant affinity with the person I saw in the few photos I found there; she was eccentric, strange, and smiling.

Why hadn't I learned about this incredibly prolific artist in art school—and what could I do to surface her story?

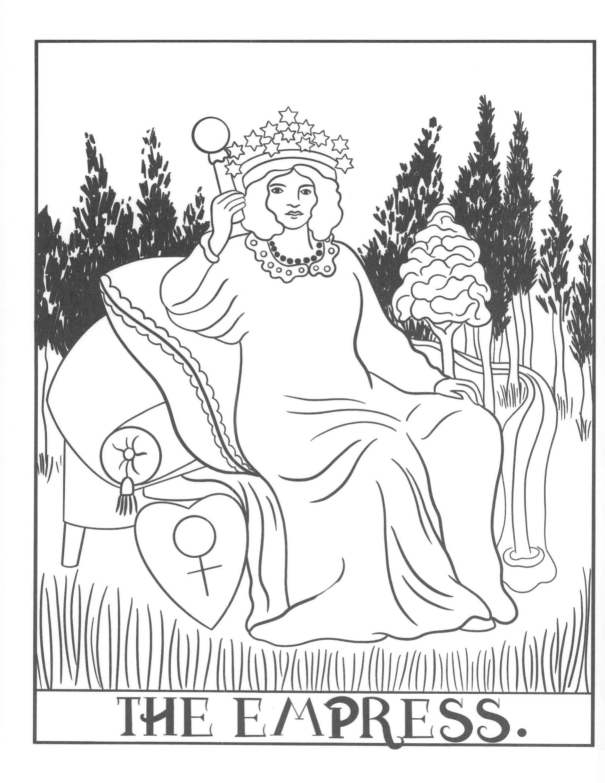

THE EMPRESS.

EARLY YEARS

1878 — 1896

Corinne Pamela Mary Colman Smith was born in Middlesex, England, on February 16, 1878.

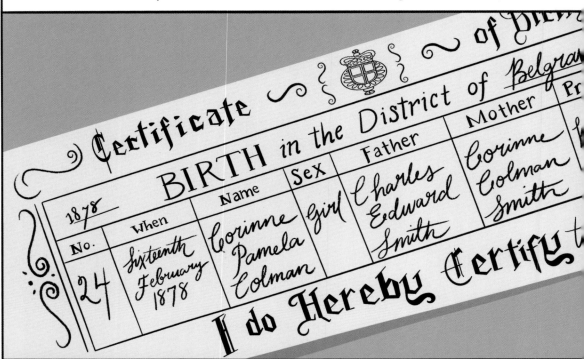

Certificate ~ *of* ~

BIRTH *in the District of Belgra*

1878 No.	When	Name	Sex	Father	Mother	Pr
24	Sixteenth February 1878	Corinne Pamela Colman	Girl	Charles Edward Smith	Corinne Colman Smith	

I do Hereby Certify

The day was gray, foggy, and cold, as her mother, Corinne Colman Smith, labored to bring her only child, her beloved "Pam," into the world.

The moody weather was an omen of a complicated life to come—

one filled with struggle, ambition, and the desire to leave things more beautiful than how they were found.

Pam was raised by Corinne and Charles Edward Smith, . . .

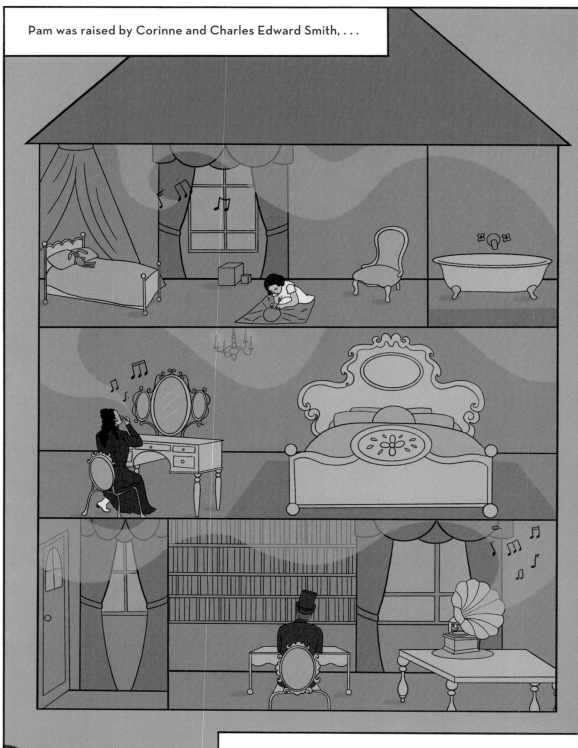

in a household overflowing with enthusiasm for the arts.

The family lived in England until Pamela was 10, first in Chislehurst when she was a toddler . . .

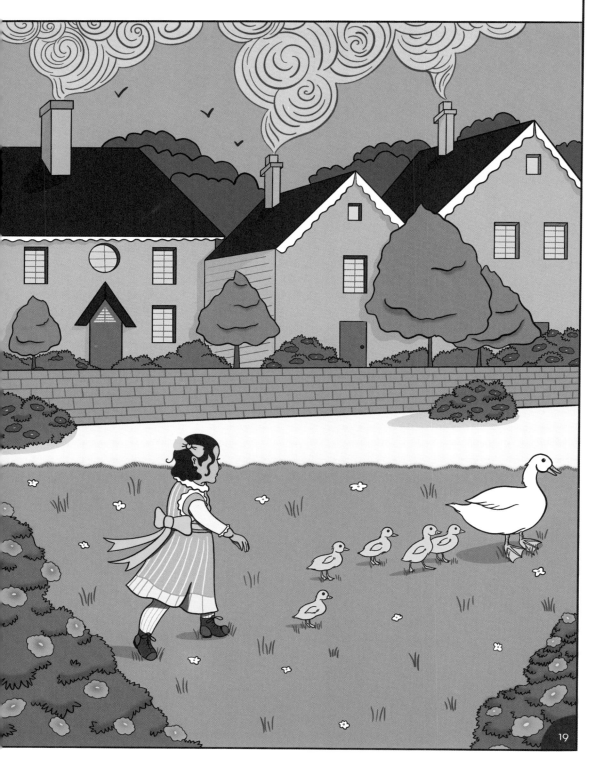

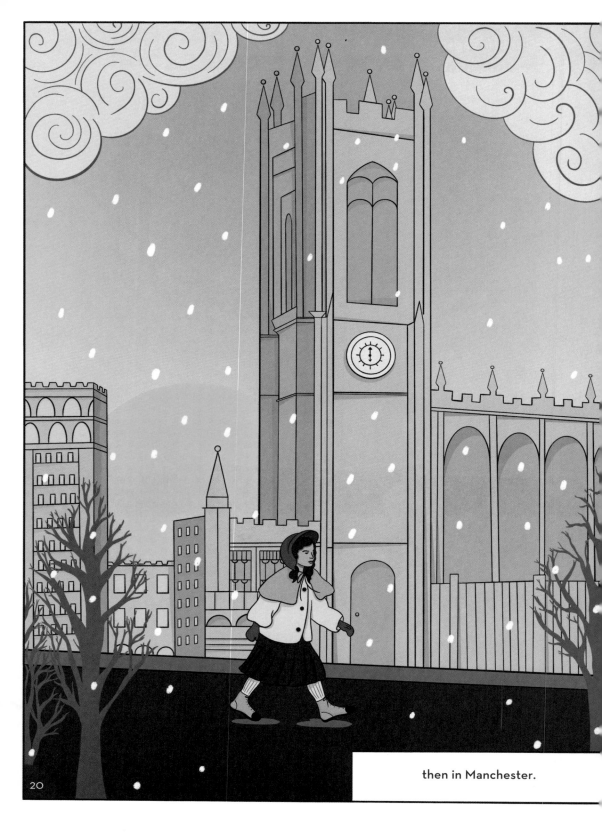

then in Manchester.

Corinne's background is largely unknown, although she was possibly of Jamaican descent and was most likely born in Brooklyn, New York.

An amateur actress, she was passionate about frequenting the theater and shared her love of the stage with her little Pam, who channeled that enthusiasm throughout her life.

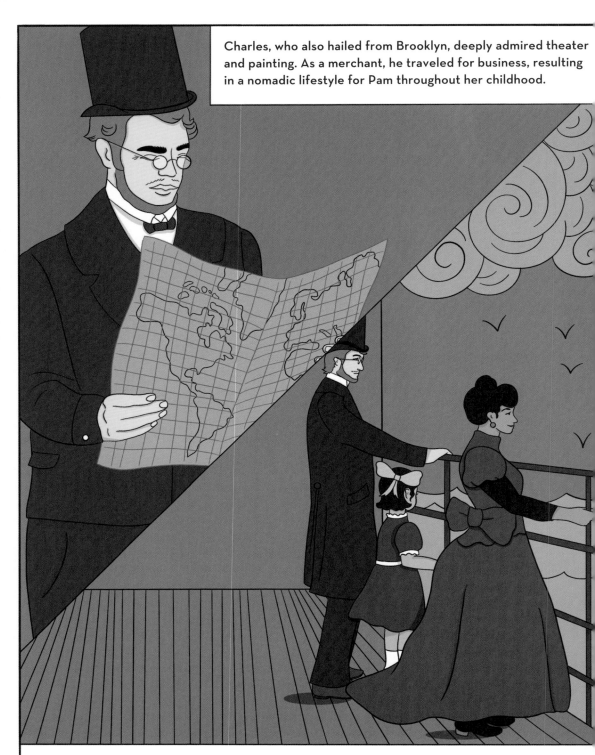

Charles, who also hailed from Brooklyn, deeply admired theater and painting. As a merchant, he traveled for business, resulting in a nomadic lifestyle for Pam throughout her childhood.

The family traveled between New York, England, and Jamaica. During that time, international travel was primarily by ship, so the family was often at sea for long periods of time.

Spending her early childhood years just outside of Manchester, Pamela was exposed to the fight for women's rights and suffragette* ideals in this particularly progressive region of England. The Manchester Society for Women's Suffrage was founded 11 years before Pamela was born, and though it was a divided movement, it managed to spread feminist thought to London, Scotland, and Ireland, and eventually throughout Northern England.

*Suffragette (noun) – A woman seeking the right to vote through organized protest.

ES

EQUALITY
~ FOR ~
WOM

TES

OR

MEN

=MANCHESTER=
Society
FOR
women's
suffrage

WE WANT
the
VOTE!

Pamela often lived with guardians while her parents were away for business, spending many of her formative years under the supervision of very interesting caretakers.

These included Dame Ellen Terry. . .

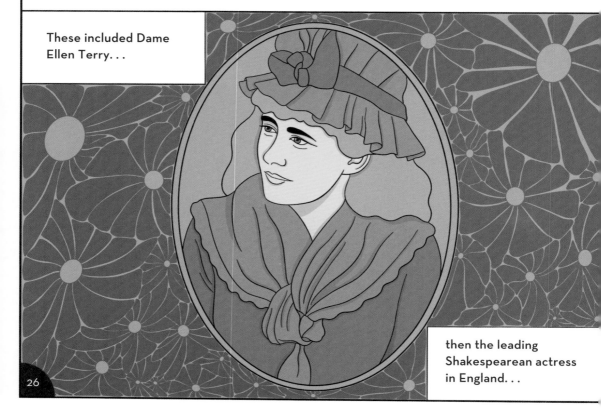

then the leading Shakespearean actress in England. . .

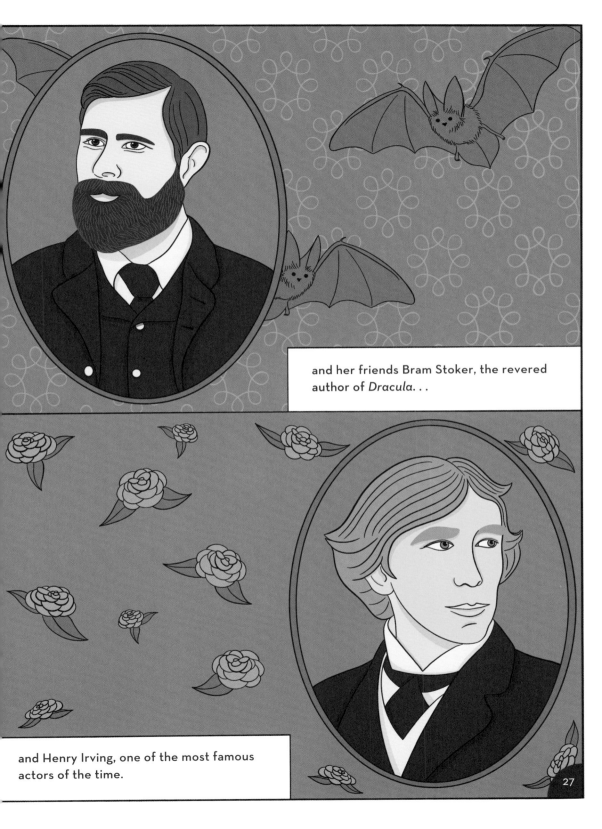

and her friends Bram Stoker, the revered author of *Dracula*. . .

and Henry Irving, one of the most famous actors of the time.

The entire staff of Ellen Terry's Lyceum Theatre company took Pamela under their collective wing. This early exposure to the theater would have a lifelong impact on her illustration work and her deep-rooted love of stage design, costuming, and performance.

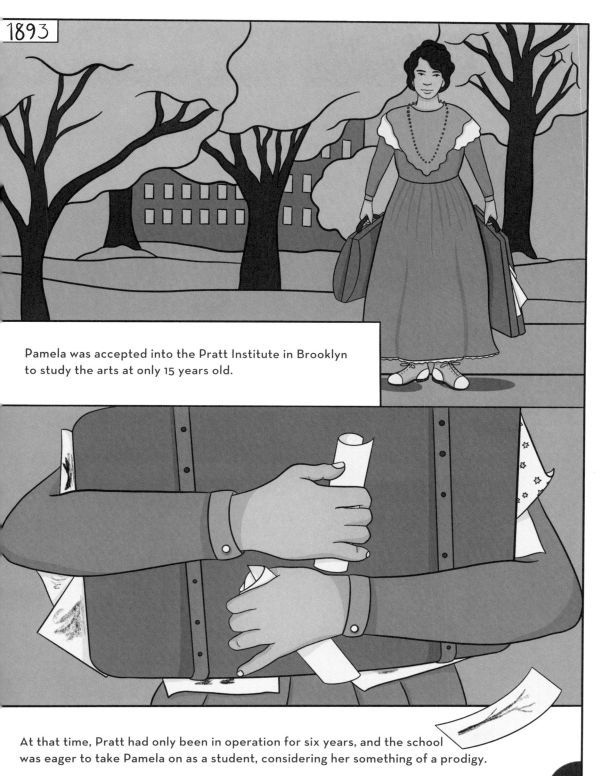

1893

Pamela was accepted into the Pratt Institute in Brooklyn to study the arts at only 15 years old.

At that time, Pratt had only been in operation for six years, and the school was eager to take Pamela on as a student, considering her something of a prodigy.

At school, Pamela developed a fascination with Japanese woodblock printmaking, . . .

which would later come into play as an important influence on her illustration style.

Tragically, Corinne
became ill in Jamaica while
Pamela was still at Pratt.
As a result, after four years
of study, Pamela left the
institute in 1896 without
earning a degree.

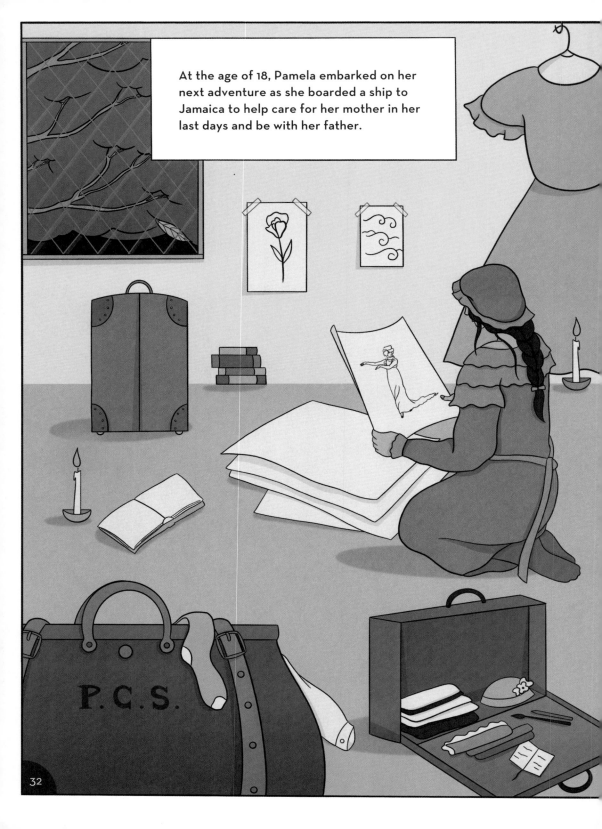

At the age of 18, Pamela embarked on her next adventure as she boarded a ship to Jamaica to help care for her mother in her last days and be with her father.

P. C. S.

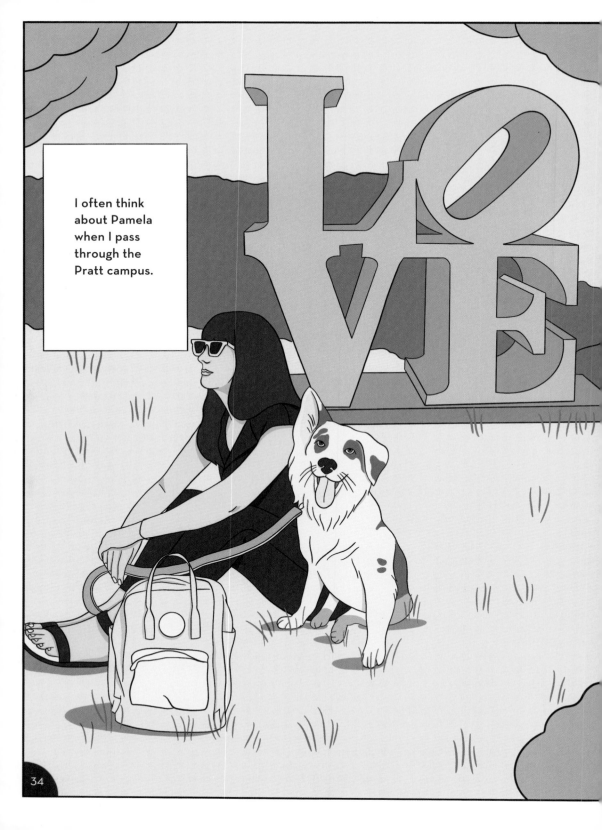

I often think about Pamela when I pass through the Pratt campus.

I have my own memories here—of visiting friends who studied in these buildings, sitting in on their classes, . . .

and coming back for the Comic Arts Brooklyn festival each year.

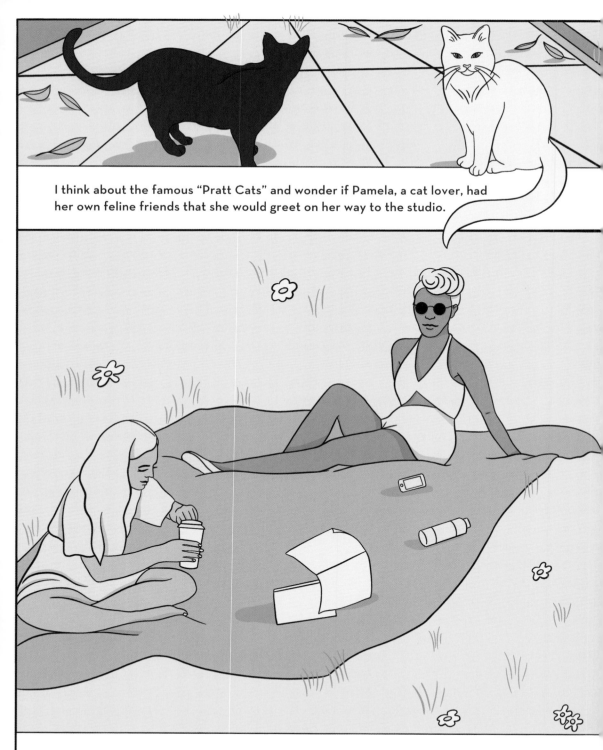

I think about the famous "Pratt Cats" and wonder if Pamela, a cat lover, had her own feline friends that she would greet on her way to the studio.

How different it must have felt for her in 1893, as only a young teen and one of few women in her circle to attend college.

Tragedy took Pamela out of school early, yet she had still dedicated a full four years to her studies, even if her area of interest was somewhat obscure.

In 2022, I still face skepticism from family and friends for my career choice, so her trailblazing bravery is mystifying to me.

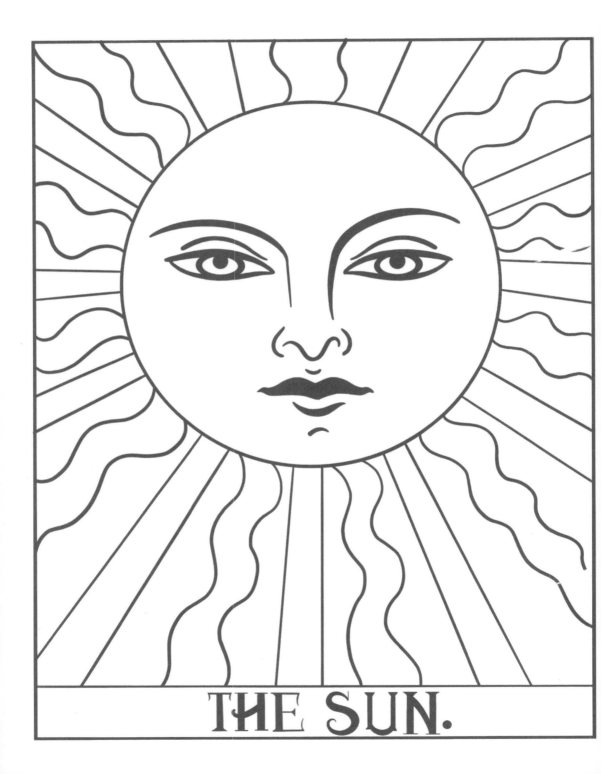

THE SUN.

JAMAICA

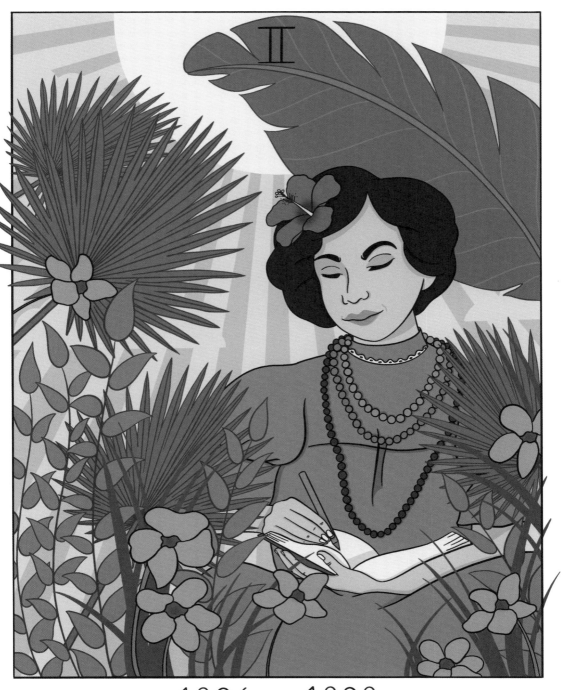

1896 — 1898

As Pamela stepped off the ship that carried her into Kingston's port, the warm, familiar Caribbean air fluttered through her hair. She was eager to be on land after her journey and noted that she wouldn't be needing the layers she had worn to keep warm in her drafty New York apartment now that she was in a place where the heat hung heavy in the air.

The warm weather would be healing, both physically and mentally. The bustle of the port was different than that of Brooklyn, and the sweet smells reminded her of trips she had taken to the island with her parents, although this time her mother wasn't along for the voyage.

Pamela's mother died shortly after she arrived in Jamaica, and the young woman took on the role of running the family home for her father and herself.

Though she was grieving, teenage Pamela was eager to get to work.

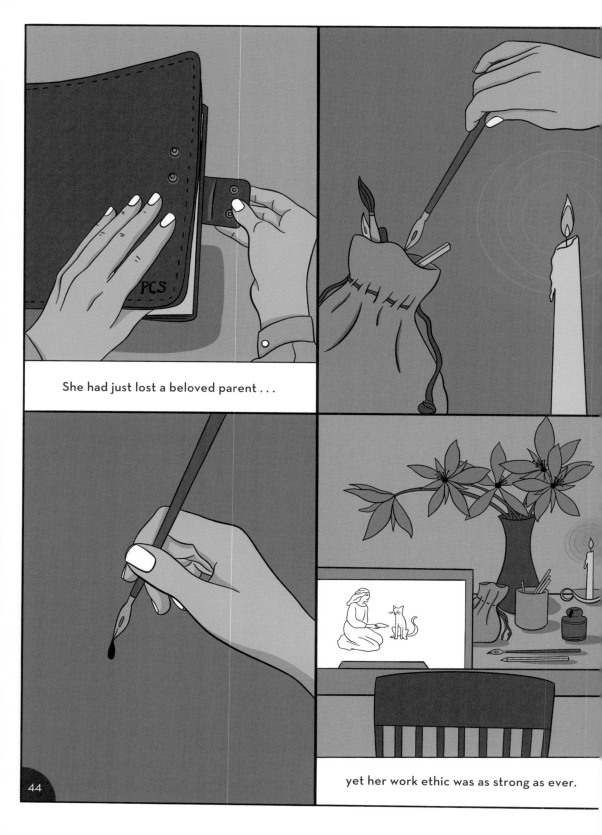

She had just lost a beloved parent . . .

yet her work ethic was as strong as ever.

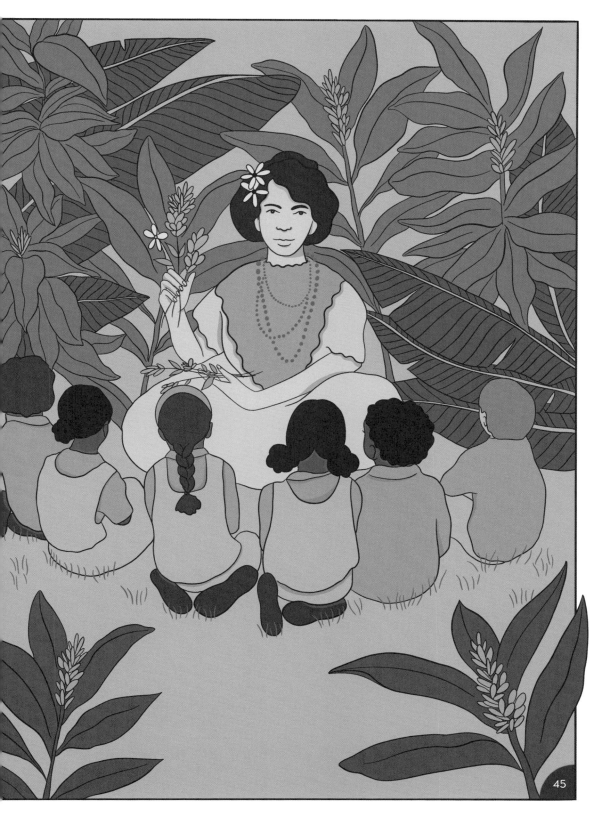

Maybe she missed a classroom environment after her recent time at Pratt, or perhaps she just needed the money. Either way, she began work as the head of a kindergarten, taking more than 100 small children between the ages of two and nine under her wing.

This was Pamela's first foray into teaching, yet it seemed to come naturally to her.

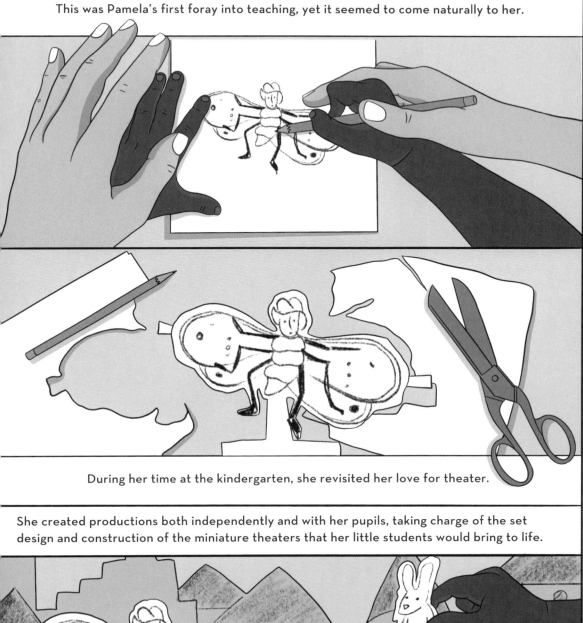

During her time at the kindergarten, she revisited her love for theater.

She created productions both independently and with her pupils, taking charge of the set design and construction of the miniature theaters that her little students would bring to life.

During these years, the impact of Jamaican folklore and storytelling began to appear in Pamela's life.

Since her mother may have been of Jamaican descent, the tales of the island may have made her feel closer to her roots.

Or maybe the young woman wanted to revisit her childhood and pay homage to the stories she grew up with.

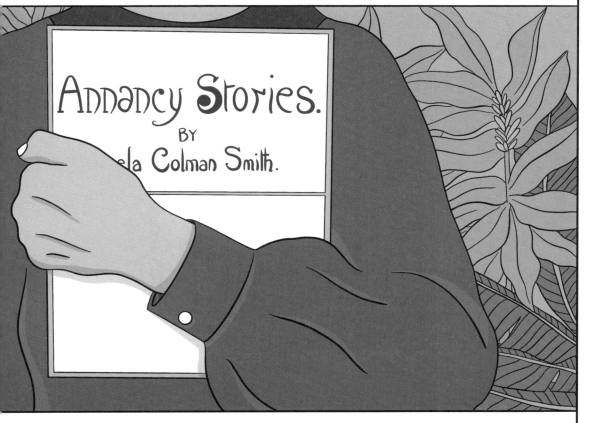

In 1896, at the age of 18, Pamela's first published article was printed in the *Journal of American Folklore*. She'd transcribed and illustrated a collection of Jamaican fairy tales.

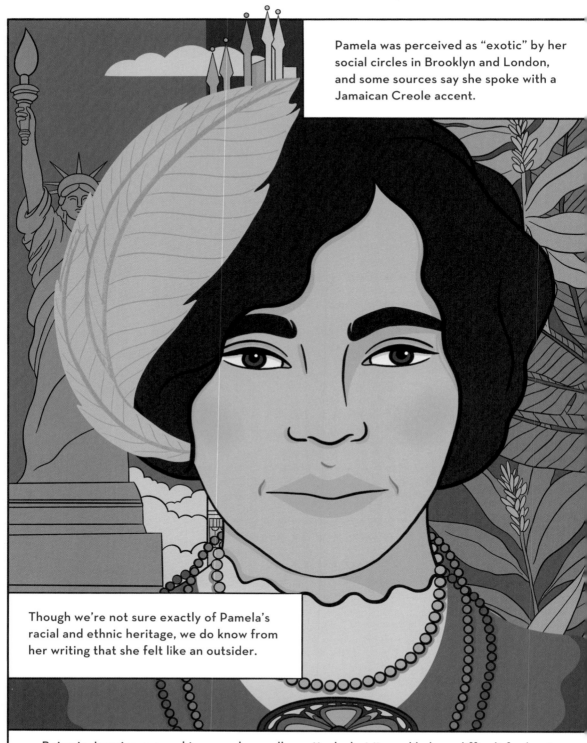

Pamela was perceived as "exotic" by her social circles in Brooklyn and London, and some sources say she spoke with a Jamaican Creole accent.

Though we're not sure exactly of Pamela's racial and ethnic heritage, we do know from her writing that she felt like an outsider.

Being in Jamaica seemed to serve her well creatively, but it was likely as difficult for her to exist there as it had been elsewhere. She was in between cultures—not fully Jamaican, not fully American, and not fully English.

1897

Pamela's time in Jamaica was cut short by her debut art exhibition at the Macbeth Gallery on Fifth Avenue.

She was reunited with Ellen Terry in New York at the age of 19.

The two continued their tradition of attending the theater together, which reignited Pamela's interest in performance. That, combined with her love of folklore, would form the multi-faceted influences that made her artistic style so captivating.

Ellen's support was incredibly important to Pamela's growth as an artist.

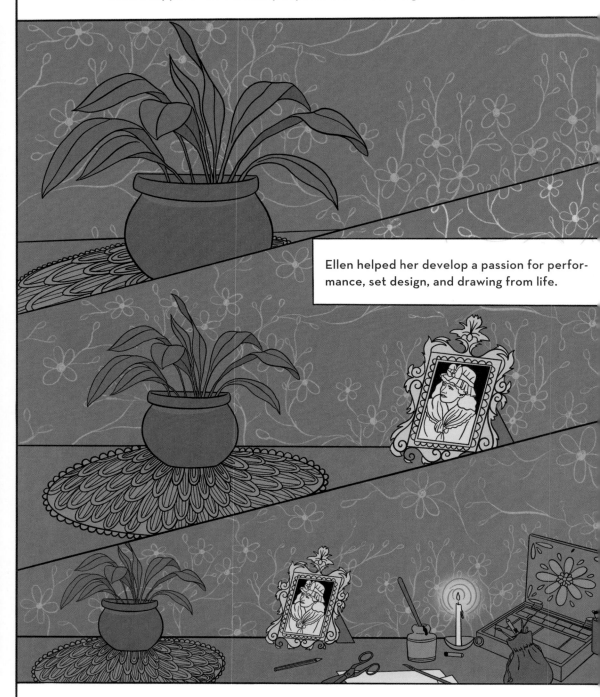

Ellen helped her develop a passion for performance, set design, and drawing from life.

Their time together led Pamela to pursue puppetry and storytelling—two skills that helped her earn an income during later artistic droughts.

"...THE STAGE IS A GREAT SCHOOL ~OR SHOULD BE~ TO THE iLLUSTRATOR ~ AS WELL AS TO OTHERS. THE STAGE HAS TAUGHT ME ALL i KNOW OF CLOTHES OF ACTiON AND OF PiCTORiAL GESTURES."

P.C.S.

53

People go, most of them, to the play
to be amused, & in spite of
themselves — are often tricked into
a mode of thinking quite contrary
to their usual habit of thought.
That is why the theatre
is the place where all beauty
of thought, of sound, of colour,
and of high teaching,
comes to be of use.

All arts — are branches
of one tree.

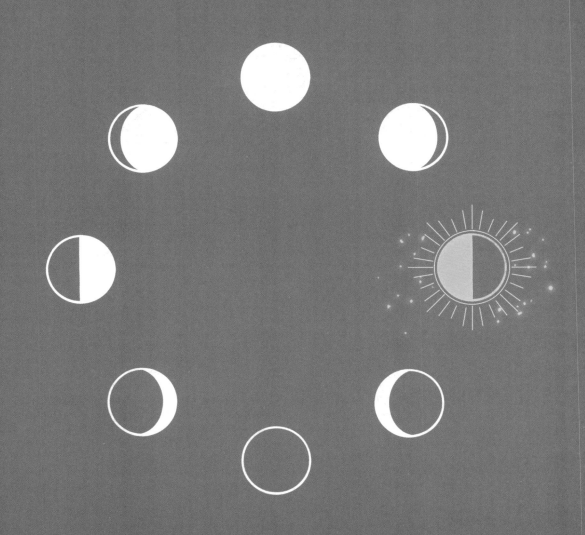

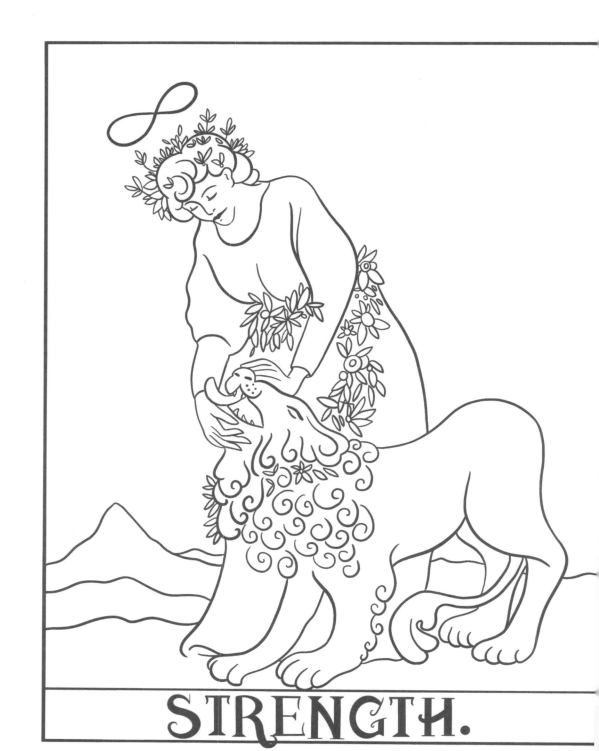

STRENGTH.

LONDON

1899 — 1909

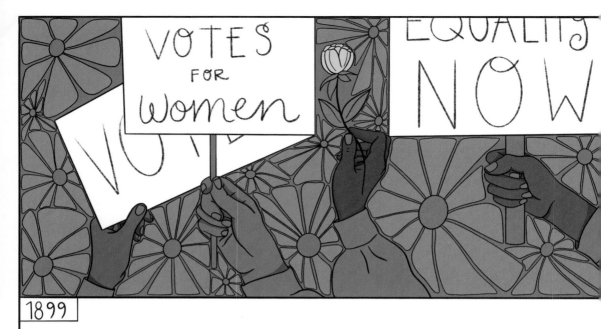

1899

It would be over 20 years before women had the right to enter a profession, sit on a jury, or be awarded degrees and almost 30 years before women could vote in the UK.

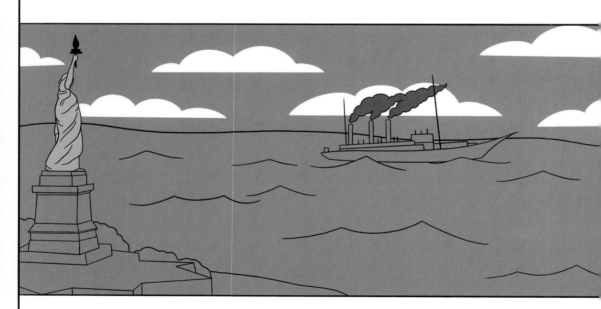

In spite of the fact that women were treated as second-class citizens, Pamela decided to move back to England alone at the age of 21 to make her way as an artist.

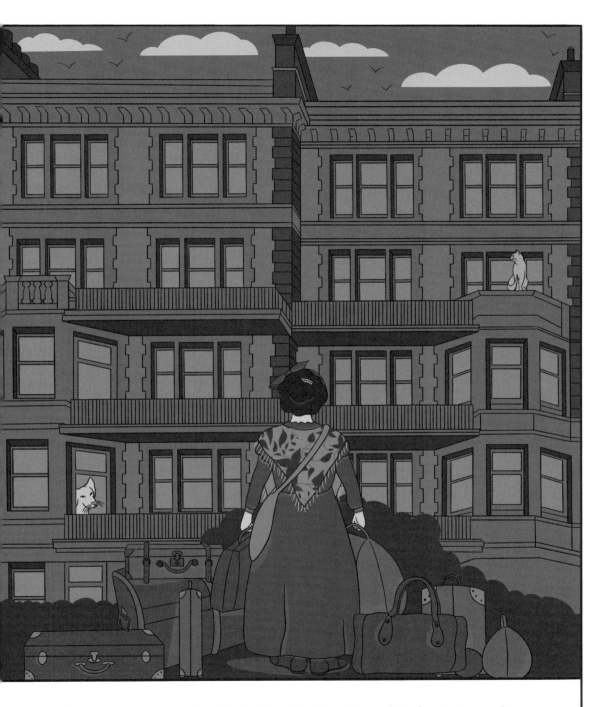

Upon becoming a permanent resident of London, Pamela was full of optimism, and she decided to only return to New York for specific career opportunities. After moving around for so much of her young life, Pamela was finally building a stable little home of her very own.

She rented a cozy apartment in Battersea Park, which she decorated eccentrically as a place filled with work, friends, stories, and warmth to counter the cool English weather.

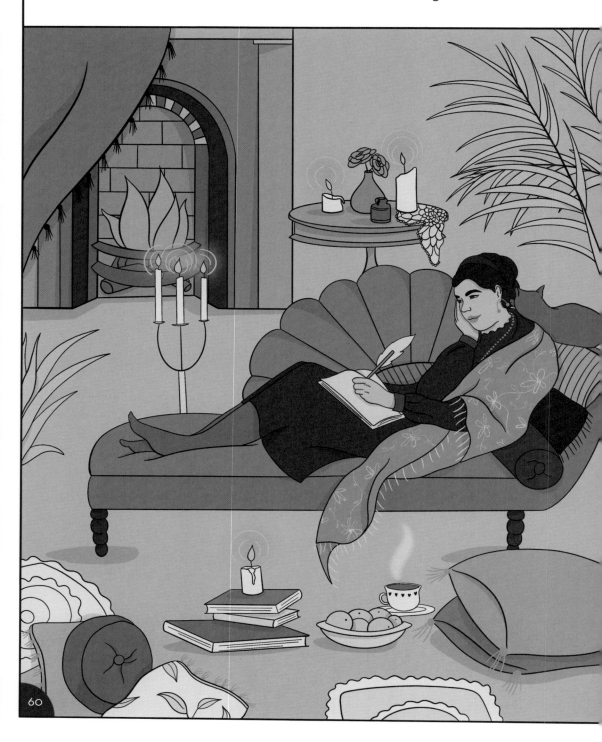

Pamela's excitement was short-lived, however.

Her beloved father passed away soon after her move across the sea.

Only three years after her mother's death, losing her father meant that she was completely alone. . .

and without any close family ties at a relatively young age.

During a time that wasn't friendly to young women without husbands, children, or a hefty inheritance. . .

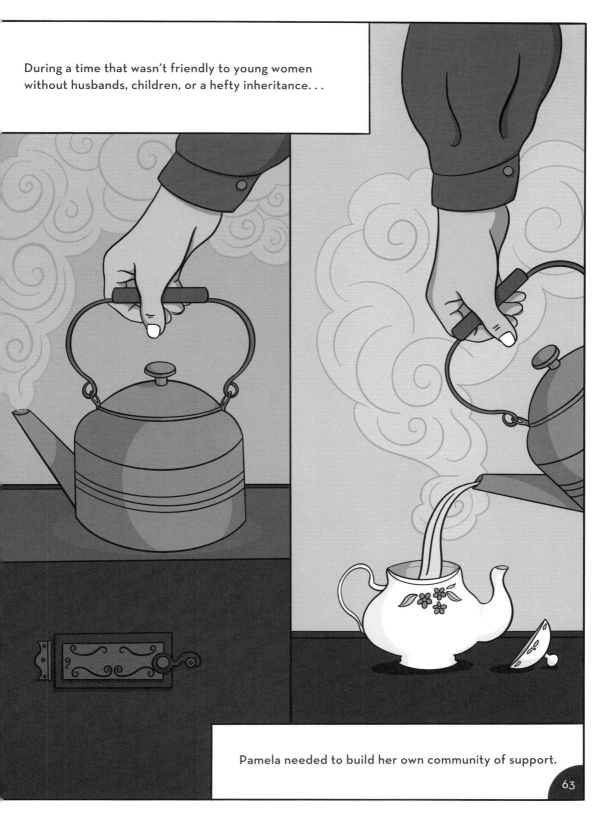

Pamela needed to build her own community of support.

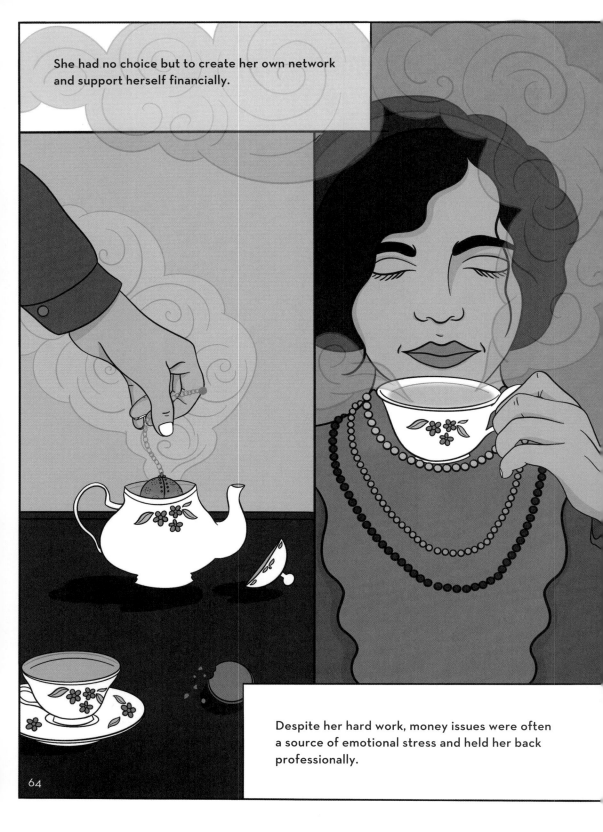

She had no choice but to create her own network and support herself financially.

Despite her hard work, money issues were often a source of emotional stress and held her back professionally.

After her father's death, Pamela filled her life with friends. Her chosen family was full of creatives who would later become notable figures. . .

including the Irish poet William Butler Yeats, the American painter Alphaeus Cole, and the English writer Arthur Ransome.

Pamela also reconnected with her childhood mentor actor Henry Irving and Ellen Terry's children, Gordon and Edy Craig. It was through these relationships that Pamela's identity as an artist really began to take shape. She fascinated the people around her, and it was a time of great artistic development and self-exploration.

Reborn during this period with the nickname "Pixie," she began to host weekly parties where she would perform the Jamaican tales she had memorized, as well as stories she wrote. Her home was a gathering point for London creatives on the scene, a place where poetry and songs were recited, art was made, and music was played—with Pixie's parlor room performances as the main attraction.

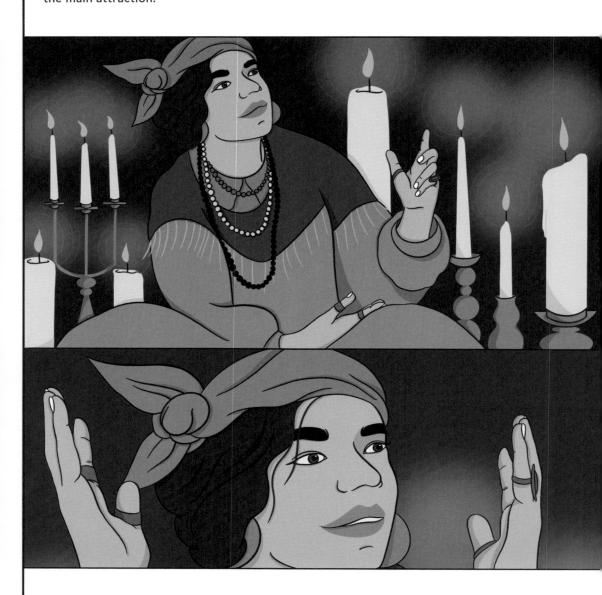

She also donned the stage name Gelukiezanger, which translates from Afrikaans as "Happiness Singer."

Pamela earned her reputation as a deeply imaginative, freethinking, funny, and playful artist who brought talented people together.

She and her friends were the start of the bohemian movement in the UK as unconventional beings who wanted more from life than what they'd been given, and created a new lifestyle together, free of rules and limitations.

Throughout the stories, folktales, postcards, prints, and plays she illustrated, one theme was a constant in Pamela's work: women. They were always the focal point of her drawings and always depicted as bold, joyful, and active—defying Victorian standards.

During the late 1800s and early 1900s, the demand for illustration in the United States resulted in some female artists such as Jessie Willcox Smith, Violet Oakley, and Elizabeth Shippen Green launching successful careers. Still, the job market favored male illustrators. Although illustration was one of the few artistic fields in which a woman could make a living, female illustrators were often confined to work that exercised their maternal inclinations, such as nursery rhymes, ads for domestic products, and children's books.

If a woman were to develop artistic skills, it was more common for those belonging to aristocratic groups, in which painting or drawing was seen as a leisurely act for the wealthy rather than as a career.

And although illustration was in vogue in the United States, few women achieved success as illustrators in England.

By pursuing illustration as a career, Pamela was taking a very big risk.

Jack Yeats was an accomplished visual artist and one of Pamela's many collaborators.

Feeling disenfranchised by their lack of acceptance from commercial publishers, Pamela and Jack set out to create their own periodical, which they called *A Broad Sheet*.

By 1902 the duo, with the help of a friend, was distributing copies of the publication from their homes.

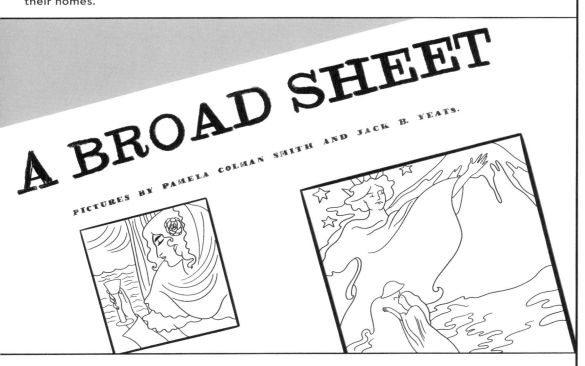

A BROAD SHEET

PICTURES BY PAMELA COLMAN SMITH AND JACK B. YEATS.

They shared their illustrations and writing, as well as entries from various contributors within their local community. Essentially, they created their very own zine.

Hoping to escape the sexism she had encountered with commercial publishers through her independent venture, . . .

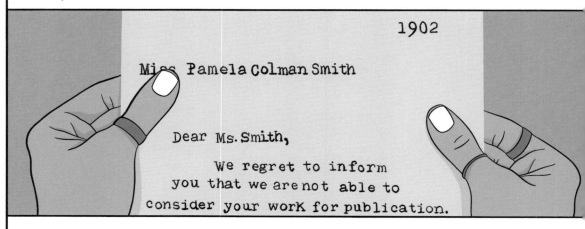

Pamela was disappointed to find that even her personal projects were plagued by disrespect.

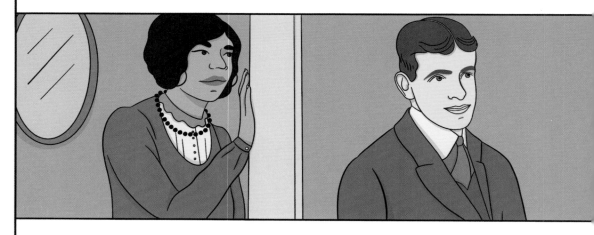

Even her good friend and collaborator Jack looked down on her.

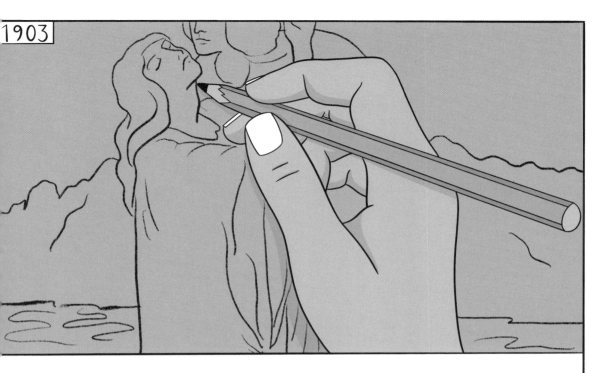

Pamela responded by setting off on her own:

"Hand-coloring each copy of *A Broad Sheet* is far too time-consuming and not profitable enough. . .

The Green Sheaf

No. I

I'm going to focus on my own magazine from now on—*The Green Sheaf*. It will be more robust and include contributions from trending artists of the time, allowing me to be fully in charge of the overall vision and editing. . . .

Sharing the visual arts duties with other illustrators allows me to focus on my own creative expression, such as my poetry."

A HYMN IN PRAISE OF NEPTUNE.

Of Neptune's empire let
At whose command the
To whom the rivers
Down the high m
To whom the sc
Homage for th
 Wh
And every
Yearly
To d

T

CLOSED
for
BUSINESS

However, after getting 13 issues under her belt, this venture also failed to turn a profit, and Pamela instead shifted her efforts toward opening a print shop of her own. The print shop's fate was similar, with the project ultimately failing to reach financial success and falling by the wayside.

There is a strong connection between Pamela's independent magazines and modern-day feminist zine culture. Well ahead of her time in such matters, Pamela wasn't afraid to explore this medium to express herself and boldly took on risky projects as a lead editor. Yet it seems that the struggle of monetization was constantly looming over any project she took on.

Though the periodicals
weren't financially successful,
Pamela was proud of the work
she created during these years,
establishing a platform to
share her art with the world
as well as making a foray
into indie publishing.

Pamela's work wholly consumed her throughout her 20s.

As she worked tirelessly on her illustration projects, performance art, and storytelling, there wasn't much time left for romantic pursuits.

Rather than marrying or pursuing male companionship, Pamela bypassed the cultural norms of the moment by supporting herself financially instead of relying on a domestic partner.

And it's up for debate whether she was even romantically interested in men.

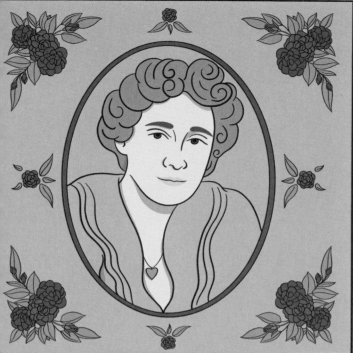

Pamela had a long-term friendship with Edy Craig, and the two may have been lovers. Edy was public about her homosexuality and a staunch advocate for women's rights. She was one of the first suffragettes in England.

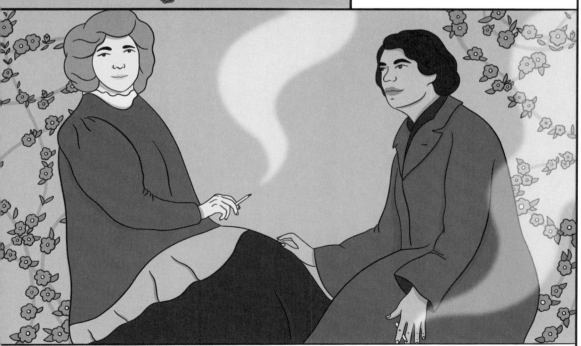

The two spent time together along with other friends at Terry's property in Kent, Smallhythe Place, where they wore pants and smoked cigarettes—behaviors that were seen as feminist rebellion. In a time when homosexuality was still a criminal offense and one could be imprisoned for their sexual identity, these women were clearly fearless.

"YOU, YOUNGER STUDENTS, WHO ARE ENTERING THIS GARDEN OF TOIL, WHERE FLOWERS ARE GROWN BY LOVE & PATIENCE, WHY DO YOU NOT TRY TO BE TRUE TO YOUR BETTER SELVES..."

P.C.S.

This was a difficult time for women generally, as they could claim very little as their own. As Pamela reached the bottom of her savings time and time again, her uncle—whose name is not known for certain but may have been Theodore E. Smith—eventually traveled from America to London to assist with her financial issues after several unprofitable publishing attempts.

However, the state of her financial affairs would shift,
at least temporarily, in the next few years.

It was a blustery November night in Battersea Park.

Pamela Colman Smith sat down at her writing desk. Wrapping a shawl around her shoulders in her stylish bohemian apartment. . .

and pulling a piece of stationery from her drawer, she dipped her pen into a bottle of deep black ink.

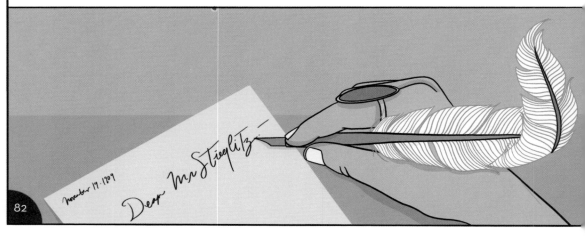

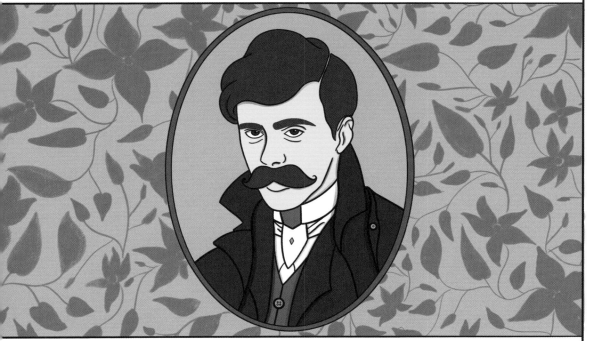

november 19·1909

Dear Mr Stieglitz —

I wonder where you are !! — I want some money for Christmas !

It had been two years since she'd made the acquaintance of Alfred Stieglitz, a gallery owner in New York City. He would later become one of the most revered photographers of the period, and was also the famed romantic partner of painter Georgia O'Keeffe.

When Stieglitz was introduced to Pamela's work, he immediately invited her to exhibit at his Midtown Manhattan gallery 291 in 1907. She went on to have three shows curated by him, which provided some financial relief, as well as attention in New York.

She was the first non-photographer, as well as the first woman, to be exhibited at Stieglitz's gallery.

She created the imaginative drawings while listening to music, and her work captivated the Manhattan art scene. The show sold out as collectors eagerly purchased her visionary creations.

Her art was so popular in New York that the show's closing date had to be extended to accommodate the influx of visitors to the gallery, despite the extreme winter weather.

Over 2,000 people made their way to Pamela's show, including the Whitney and Vanderbilt families, resulting in acclaim for the young artist.

BROOKLYN LIFE

VOL. 1 BROOKLYN, 1907 5¢

Pamela Colman Smith is a gentle woman, presenting an odd type of thoroughly unconventional femininity, and therein lies her greatest charm.

It was around the time of the first exhibition that she began to receive press.

"the place was literally mobbed."

On this evening of November 19, 1909, though, she wasn't only writing to Alfred to ask for her check from artwork sales. She also wanted to tell him about a new project she'd just finished. A project that, at the age of 31, proved to be the most significant work of her career.

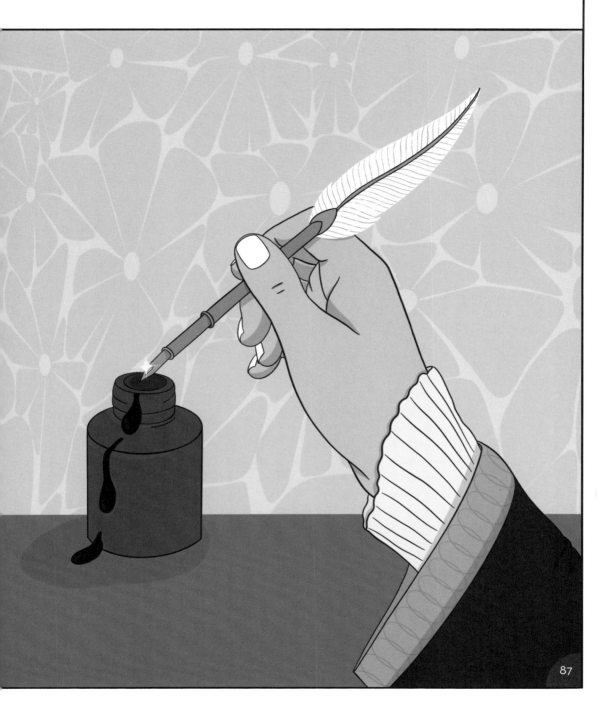

I've just finished a big job for very little cash!

a set of designs for a pack of _Tarot_ cards - 80 designs. I shall send some over — of the original drawings as some people may like them!

I will send you a pack —

(printed in colour by lithography — probably very badly)

— as soon as they are ready.

Not only did some people like her drawings, but they became the most popular deck of tarot cards of all time, known today as the Rider-Waite tarot deck and selling millions of packs globally.

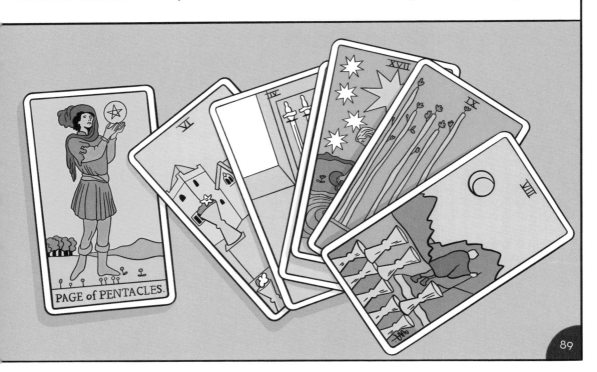

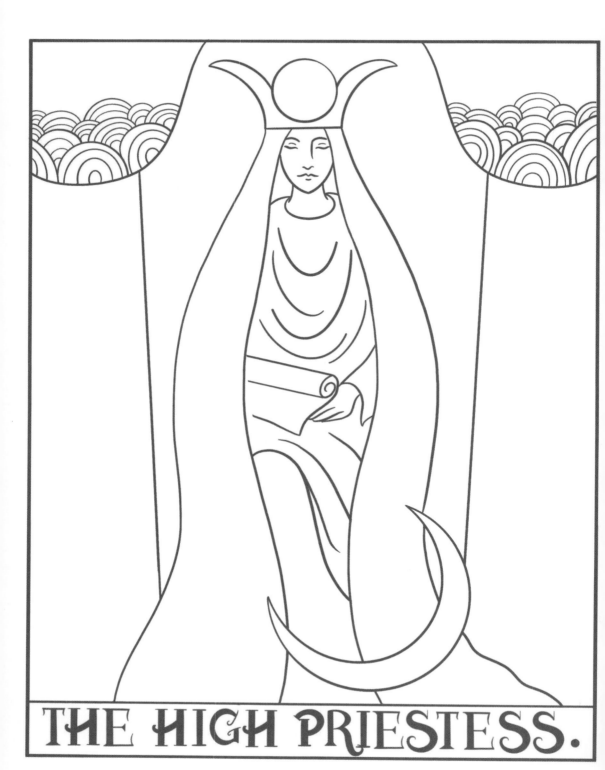

THE HIGH PRIESTESS.

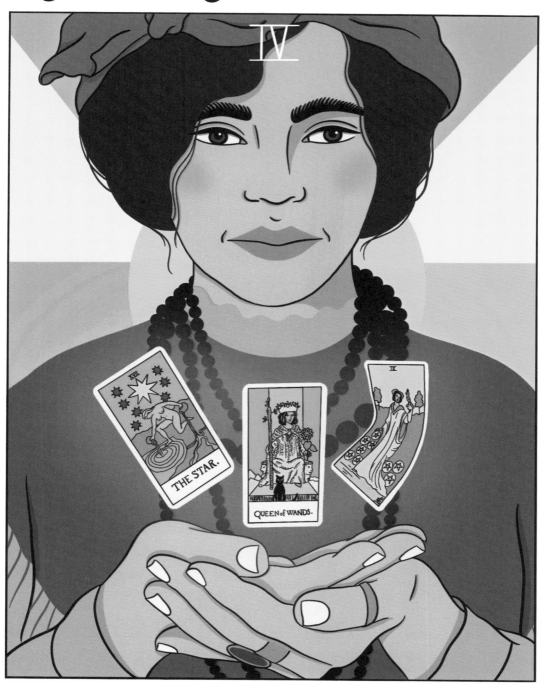

Tarot, on a basic level, is the practice of drawing cards from a deck in order to channel spiritual guidance or find a deeper intuitive insight into one's life path.

Tarot's origins are complex, but it is believed that the practice got its start in the form of playing cards, dating as far back as the 14th century in the Middle East. These cards were influenced by Chinese decks popular during the Tang Dynasty (618–906 CE).

Reserved for the Islamic elite, the cards were intricate little hand-painted works of art, used to pass the time among the wealthy male upper class.

The cards carried paintings of people, objects, and architecture, and these beautiful images ultimately caught the eye of Western traders, who brought them to Europe.

In 15th-century Italy, tarot remained a pastime for the wealthy, with rich families hiring painters to create "cards of triumph" decks. These were inspired by the Arabic class system and customized for each family.

The Sola Busca deck, said to have been created in 1491 by Nicola di Maestro Antonio d'Ancona in Venice, is the first known complete painted deck and inspired the imagery of many decks that came after.

At this time, the figures included in the drawings of most decks were primarily male. Female figures such as queens, empresses, or maidens that we see in modern decks were less common.

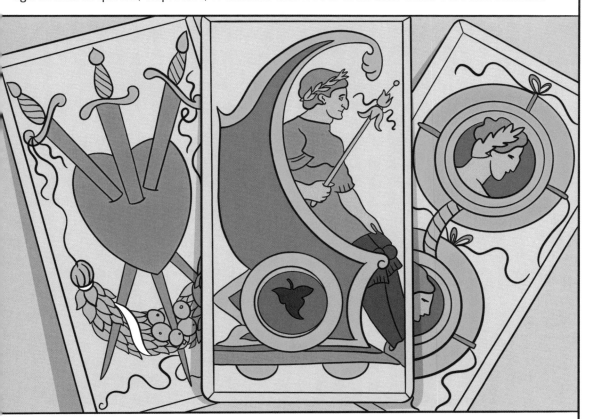

This was in part a remnant of the original Islamic structure of the cards, as well as a consequence of the rules dictated by a religious Italian governing body that modeled many of the cards after church figures like the pope.

The practice of tarot eventually traveled to France and Germany with traders and merchants . . .

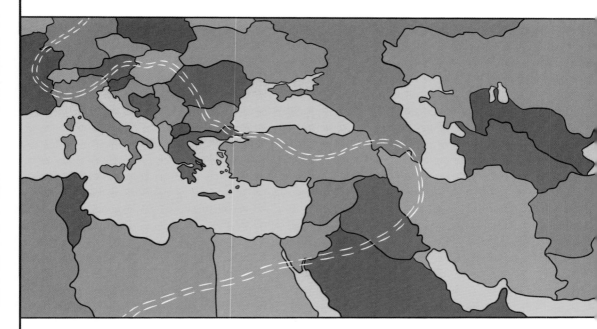

where it again experienced new artistic and cultural interpretations. The Tarot de Marseilles, for example, was a block-printed deck circulated in France, which resembles modern-day playing cards.

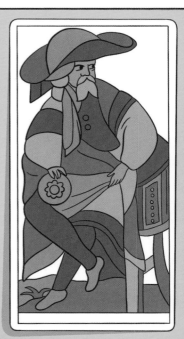

The concept of painted playing cards evolved into a literary game around the 1500s, with players writing poems in response to the cards they drew from the deck, a practice that incorporated the ideas of chance and playfulness.

Over the course of the next 300 years, European society shifted from feudalism to capitalism. By the 18th century, royal families were being phased out of government, and the class structure of many societies began to change as well. The patriarchal structures people were used to, with a single man maintaining authority in any given enterprise, were beginning to break down.

Men tried to latch on to the patriarchy at this time by developing secret societies.

These organizations were male-only, very exclusive, and are thought to have evolved from medieval craft guilds.

Secret societies allowed working-class men to maintain a position of power in society, establishing them as men of importance.

Tarot was adopted by these fraternities, with members claiming that knowledge of tarot was a privilege afforded to them for being accepted into a secret society. Members suggested that they had divine ties to ancient Egyptian secrets.

In the late 1700s Jean-Baptiste Alliette, a French occultist also known as "Etteilla," became the first known tarotist, publicly connecting the cards with the world of mysticism.

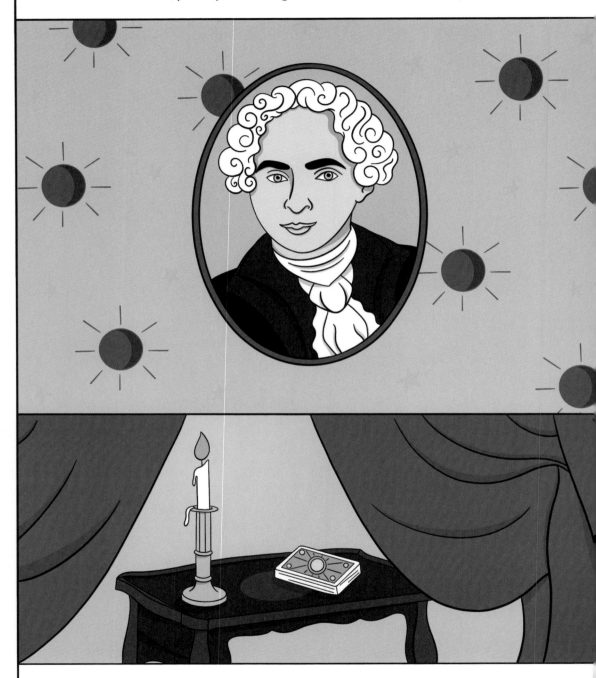

He published a book on tarot, established his own reading method, and made his living fortune telling.

Etteilla's practice is so significant because he assigned symbolic meaning to the cards, popularizing and democratizing the concept of using tarot cards for more than just a game to pass the time.

He created the first known deck expressly intended for supernatural and spiritual intentions.

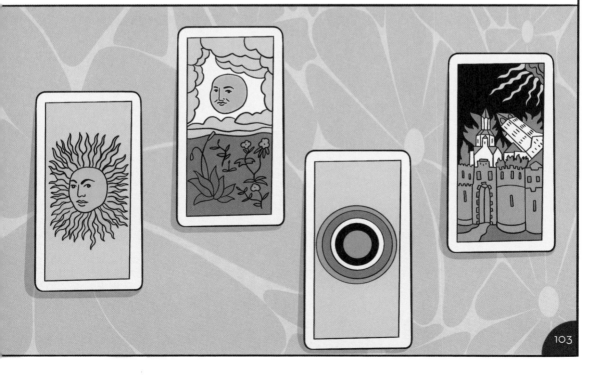

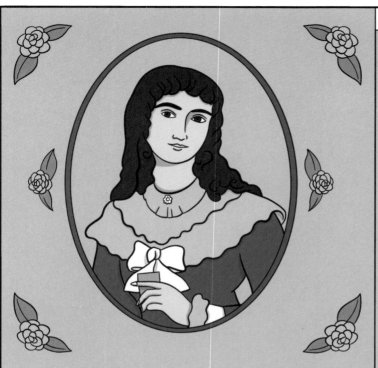

Tarot was primarily male-dominated until Marie Anne Lenormand became Paris's first female celebrity card reader.

She claimed to have learned how to read tarot from nomadic gypsy tribes and eventually become the personal tarotist of Napoleon I's wife Joséphine.

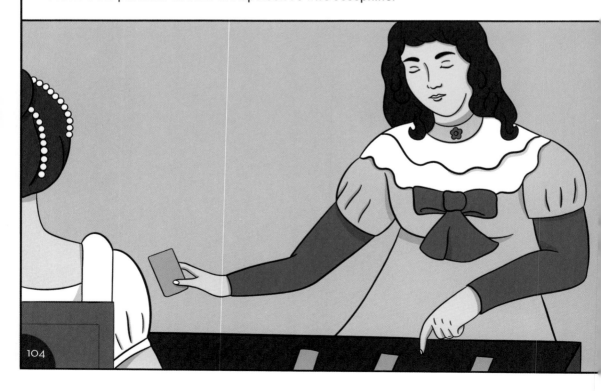

By taking her practice to the streets, Marie Anne Lenormand brought tarot out of the elite realm and into the lives of common people.

Thanks to her, tarot became more accessible in Europe, and as a result, after her death tarot decks were printed bearing her name.

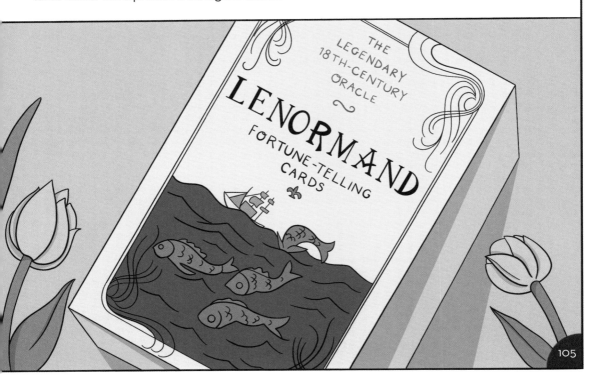

As tarot became more popular in the 19th century, its reputation also began to change. Rather than being seen as a mysterious upper-class game, it became known as a pastime that women could partake in together. At a time when jobs for women were scarce, card reading was a safe method of earning a living, and women could learn the rules from other women. The rise of printing technologies allowed for people to reproduce cards with slightly more ease, rather than hoping for an expensive hand-painted deck being passed down through the family or a secret society.

As soon as women reclaimed tarot, high-society men began to dismiss it as a silly diversion for ladies.

In the 1800s tarot faded in popularity, but it slowly began to appear more and more in the studies of a mysterious organization known as the Hermetic Order of the Golden Dawn (often simply called the Order of the Golden Dawn).

When she moved back to London from Jamaica, Pamela began to dabble in the world of the occult.

Her friend William Butler Yeats was a member of the Isis-Urania Temple of the Hermetic Order of the Golden Dawn.

Yeats suggested that Pamela join the organization, and she did around 1902.

The Golden Dawn was a secret society founded in England in 1888. It was deeply rooted in mysticism, the supernatural, and "black magic."

Members developed their spiritual practice, explored magic rituals, and studied metaphysics and paranormal activity.

The organization consisted of three different Orders, essentially hierarchical levels of practice made up of Secret Chiefs who were believed to be tapped into a deeper esoteric or cosmic world.

Women were allowed to join the Golden Dawn, which was uncommon for secret societies of the era . . .

although they didn't have quite the same access to all of the teachings that male members did.

Astrology and tarot were also important elements of the Golden Dawn.

Being a member influenced Pamela's artistic practice.

It allowed her to explore the supernatural and mystical world through her drawings and performances.

It was also at the Order of the Golden Dawn that she met her next important collaborator.

Pamela had been following the work of Arthur Edward Waite, an American-born British occult mystic, poet, and scholar, for six years.

He had been studying and writing about tarot since 1887, and sometimes commissioned Pamela to illustrate his articles for the *Occult Review*.

JANUARY 1908. FIFTEEN CENTS.

THE OCCULT REVIEW

Eventually, he approached her with his idea for an illustrated tarot deck.

Dear Ms. Colman Smith,

The job Arthur presented was an important synthesis of Pamela's interests in astrology, religion, and the occult, as well as her illustrative artwork. It required an illustration for each card in the tarot deck, which would be printed and sold as a set.

So, at the age of 31, Pamela completed nearly 80 drawings in only six months. Her tarot cards were printed in December of 1909—the same year that she had received the commission!

At this time, drawing from a live model was not considered appropriate for a woman.

With so many human forms to draw for the deck, and without photography to rely on, Pamela had to get creative with her references.

She used her friends as models and integrated structures from local cemeteries and nearby architecture to inform the buildings she drew.

Her deck was decidedly unique due to the elements and characters she added from her own life. There is a strong resemblance between Ellen Terry and both the Queen of Wands and the Strength cards.

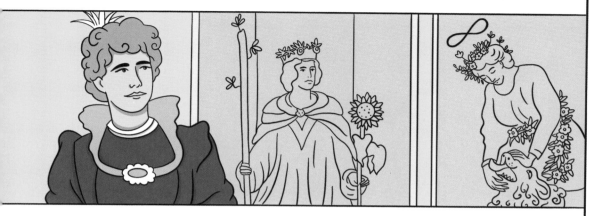

There is another parallel between Edy Craig and the androgynous Magician.

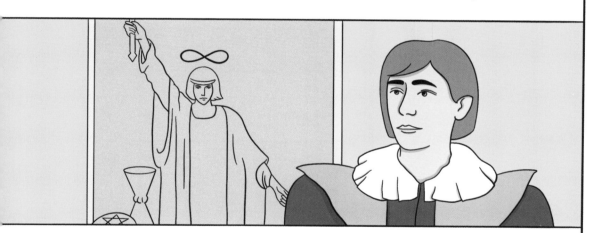

Pamela's cat Snuffles appears in the Queen of Wands card as well, kicking off the tradition of including a black cat in that card in most tarot decks thereafter.

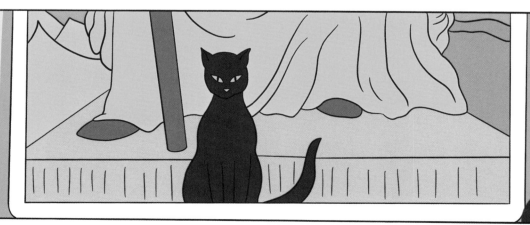

And since Pamela spent so much time drawing actors onstage in her youth, her reportage skills were sophisticated enough that she could capture the human form on paper very quickly.

She also did quick sketches of friends at her parlor parties, and this drawing practice helped her finish the illustrations for the deck on time.

Working on so many drawings for the deck consumed most of Pamela's time in 1909, but it did not sustain her financially.

She was paid less than the equivalent of minimum wage at the time, so rather than revel in her accomplishment once the deck was finished, she was preoccupied with figuring out where her next paycheck would come from.

It's sad to discover how little money Pamela earned for so many illustrations...

particularly when a single deck sold through William Rider & Son was priced at five shillings, or more than a day's work in the early 1900s.

To supplement, she earned extra income through childcare, running errands, and doing housework at Terry's estate.

Originally titled the Rider Deck after the publishing company William Rider & Son, Ltd. of London, . . .

the card set was soon reprinted as the Rider-Waite Tarot Deck to commemorate Arthur Edward Waite's involvement in the conception of the project as well as the informational guide he wrote called *The Pictorial Key to the Tarot*.

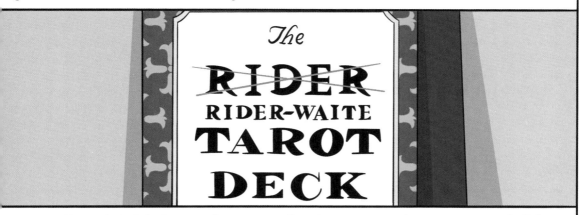

This booklet included the history of tarot, as well as descriptions and interpretations of all the images in the deck.

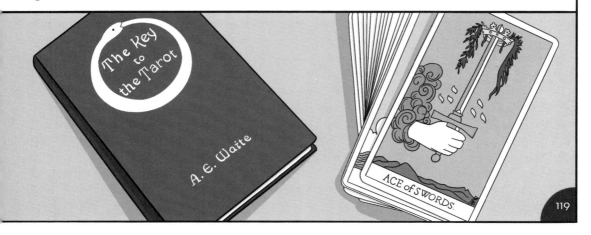

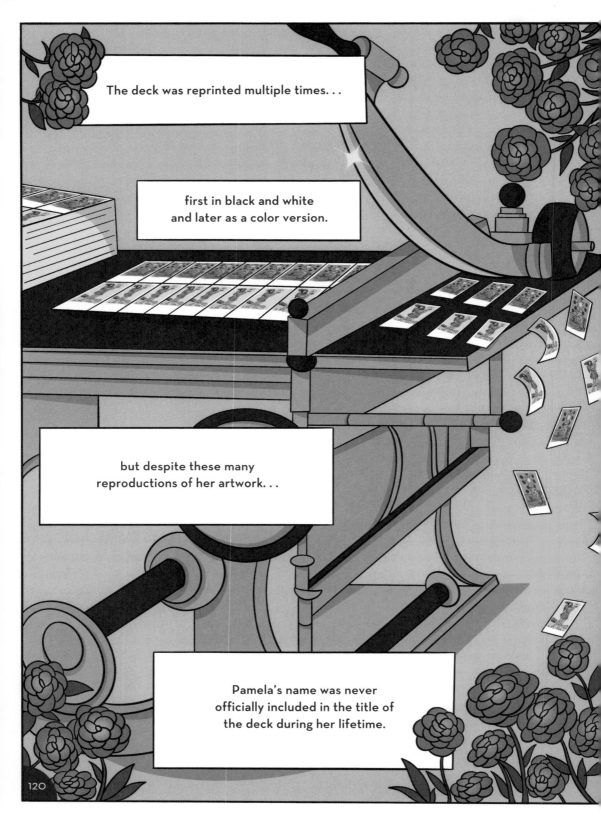

The deck was reprinted multiple times. . .

first in black and white and later as a color version.

but despite these many reproductions of her artwork. . .

Pamela's name was never officially included in the title of the deck during her lifetime.

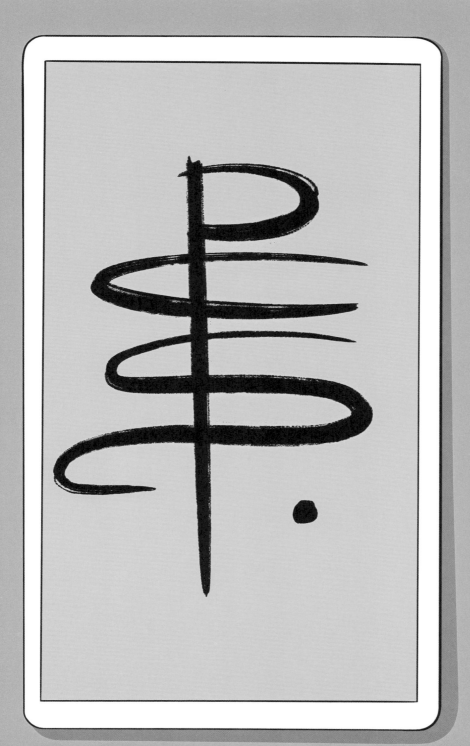

However, her signature appears on each card as a uniquely beautiful flourished monogram. Consisting of her initials PCS, this subtle inclusion ensured that Pamela's mark would be left on each drawing, even if the published title itself did not sufficiently credit her. Many tarot readers now refer to the deck as the Smith deck to celebrate the artist behind the incredible imagery.

The collaboration between Pamela Colman Smith and Arthur Waite was the first consumer-facing tarot deck on the market that was readily accessible to the public.

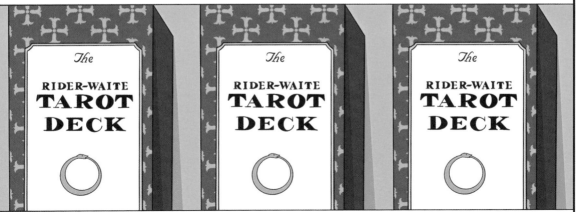

It was originally presented at a local arts and crafts fair before it became available for order at the back of certain books published through William Rider & Son and later through various occult publications.

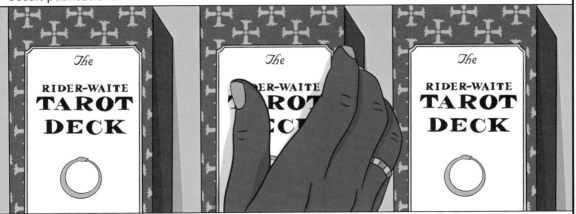

Because the deck also came with Arthur Waite's guidebook, customers could connect the philosophy of tarot to the practice, with Pamela's illustrations serving as a visual guide.

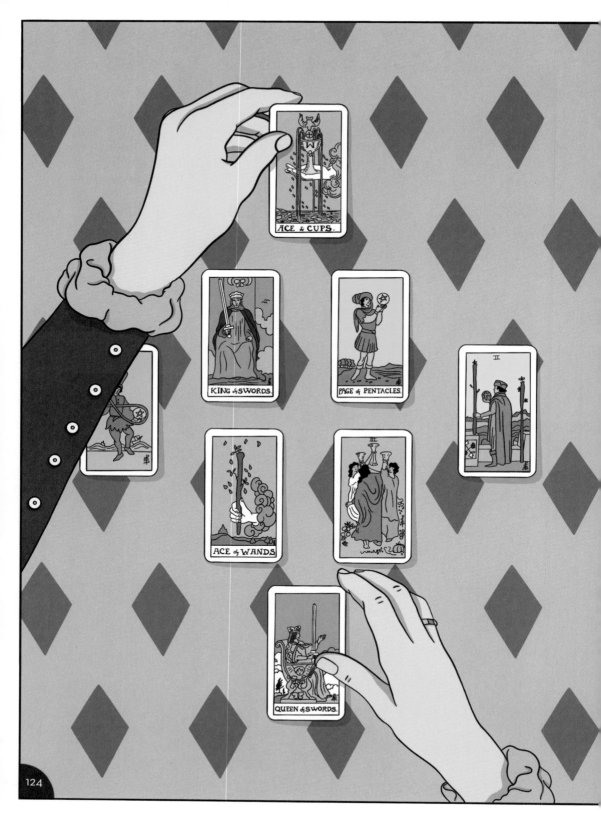

What really set Pamela's designs apart
is that each card was not only a powerful
scene, but together all of the pip cards—or the
four suits of Cups, Wands, Swords, and
Pentacles—told a unified story when laid out.

Pamela was the first illustrator to depict the Minor Arcana cards with fully executed scenes rather than merely symbols since the Sola Busca deck was created in Italy in 1491.

Prior to Pamela's deck, the pip cards were only rendered with a symbol of the suit, but she created a full scene on each card to contribute to the overall story of the deck.

She believed in a reader's ability to partake in their own ritual while reading, and the built-in narrative made it easier for everyday consumers to find meaning in the cards. A story could be revealed no matter what formation the cards took during a session.

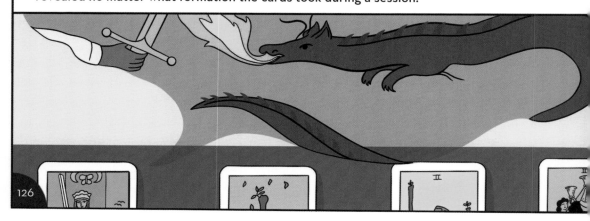

She also inserted her own voice into the deck, reimagining previously Christian-influenced cards like the "Pope" and "Papess" as the "Hierophant" and the "High Priestess."

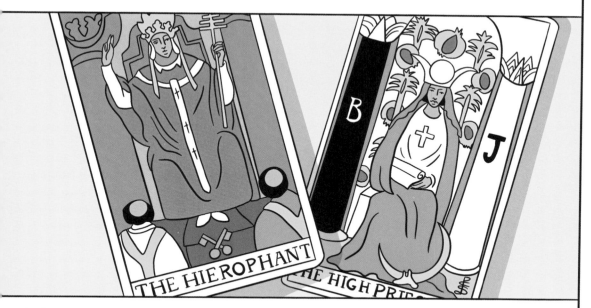

Think about that. It's one thing to produce such an abundance of drawings in a short period of time with straightforward instruction, but quite another entirely to innovate and dream up new characters and symbolic meanings under rather questionable guidance.

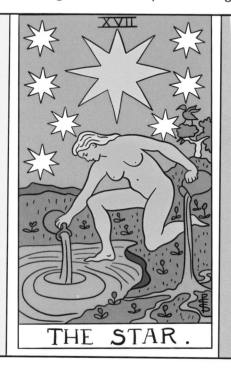

In addition to not crediting Pamela's work on the deck, her collaborator wasn't the easiest person to work with generally.

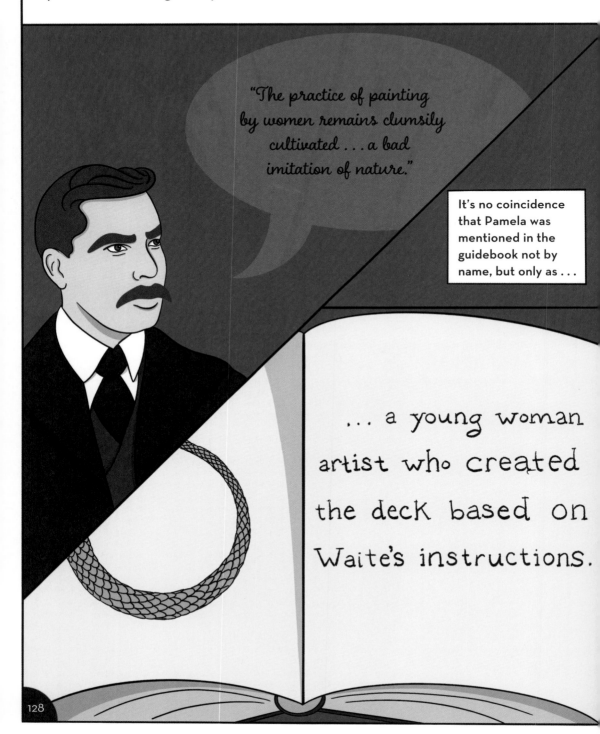

Arthur essentially claimed conceptual credit for Pamela's work.

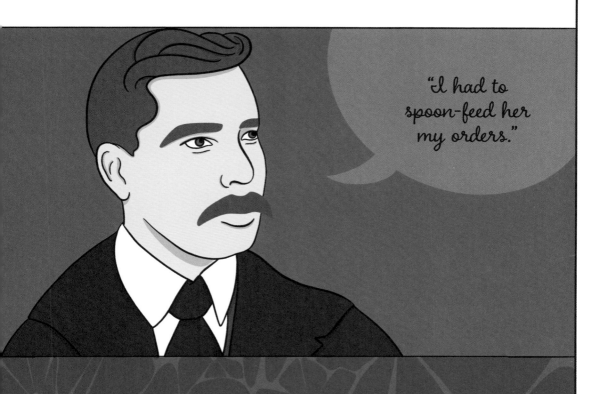

"I had to spoon-feed her my orders."

But we know that the young artist drew upon her own sources of inspiration to develop the imagery and style that resulted in the deck's incredible popularity.

Arthur also ensured that Pamela did not receive any publishing royalties, a practice that had been in place since the Middle Ages. This meant that she was not compensated beyond the initial meager payment she received for the project, regardless of how many decks were ultimately sold. Had the situation been different, with Arthur willing to share in the royalties and success of the deck, Pamela almost certainly would have had a stabler financial future.

Cruelly, it seems that time was not on Pamela's side: the 1909 Trade Boards Act, which established a minimum wage for all workers, was passed mere weeks after she finished the deck.

In 2009, Pamela's deck was republished by U.S. Games Systems, Inc. to commemorate the 100th anniversary of the project. And this edition, titled the Smith-Waite Centennial Tarot Deck, included Pamela's original color choices and is an accurate and true reproduction of the original deck from 1910.

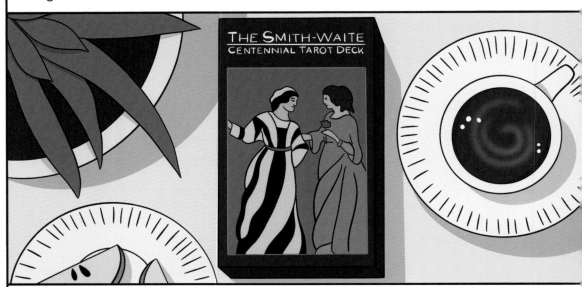

However, only this anniversary edition of the deck bears a name revised to acknowledge Pamela's work, while the standard deck continues to be printed and sold as the Rider-Waite Tarot Deck.

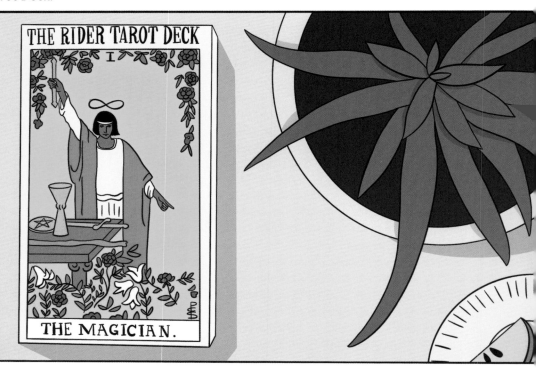

I sometimes wonder why it took 100 years for Pamela Colman Smith to be officially credited for her artwork on such an important collection of illustrations.

She earned many admirers throughout her career, including J.M. Barrie, author of *Peter Pan*, the French composer Claude Debussy, and the German fine art publisher the Berlin Photographic Company.

Pamela also illustrated several books, including collaborations with authors and stories she wrote herself.

All of this is to say that Pamela's talents extended well beyond the world of tarot, and her body of work is deeply complex, ranging from the occult to publishing, from children's books to political posters, and yet the majority of these remain unknown to the general public today.

In a time when slavery had only recently been abolished in the UK, racial tensions remained high, and it seems her "exotic" appearance—whether imagined or not—hindered her ability to gain the professional respect that should have been her due.

Understanding her varied accomplishments and the challenges she faced can help us celebrate not only Pamela's life's work, but also the many forgotten female artists who have been heavily overshadowed by their male counterparts for centuries.

Given the history of women and tarot—beginning with the exclusion from the practice, and then, later, the dismissal of tarot as a "woman's pastime," . . .

it is meaningful for a woman to have created artwork for a new deck that ultimately became the most functional collection of cards for readers.

Author Israel Regardie wrote in 1974 that Waite "had about as much insight into that [. . .] as my beautiful Siamese cats. If anything, I have a sneaking suspicion that his artist, Pamela Colman Smith, also a member of The Golden Dawn, was a strange clairvoyant creature whose inner vision must have had a greater effect on Waite than Waite did on her."

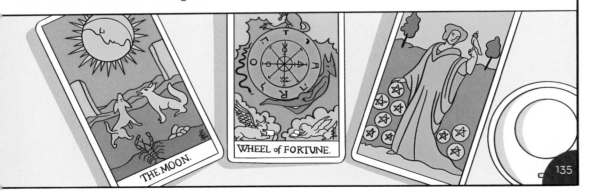

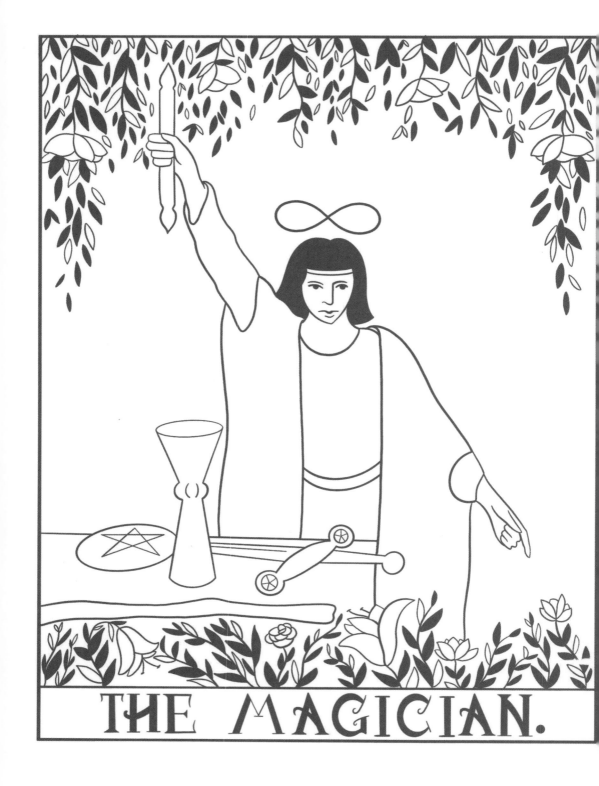

THE MAGICIAN.

ADVOCACY

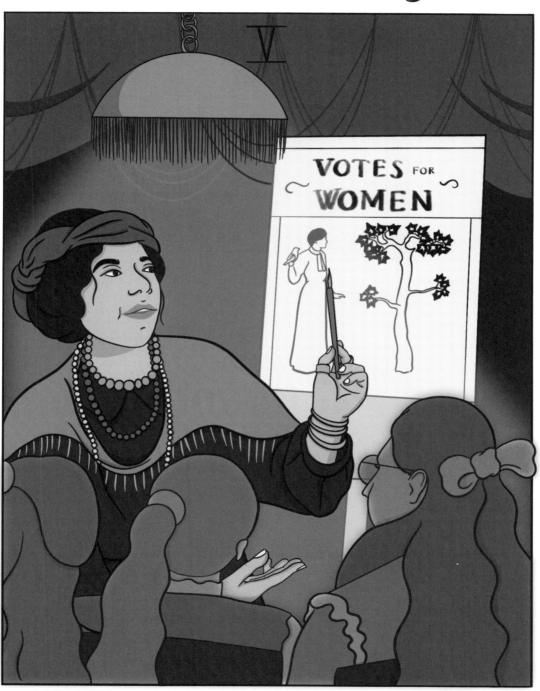

1910 — 1914

It had been a few months since Pamela completed the tarot deck. So much had changed since her youth in England, yet many things had remained the same.

Women scurried about in their layered skirts in the afternoons, running errands with little children in tow—their husbands at work while they ensured that their households continued to run smoothly.

Women were responsible for so much, yet they owned so little of their own.

The women in Pamela's life—her mother, Ellen Terry, Edy Craig, even the heroines in the stories she wrote—had shaped her identity and their influence had molded her many talents.

Yet within broader society, women still lacked a voice.

In the years to come, Pamela's interests shifted to the realm of women's rights. She joined London's Suffrage Atelier, an artist collective organized to create suffragette propaganda.

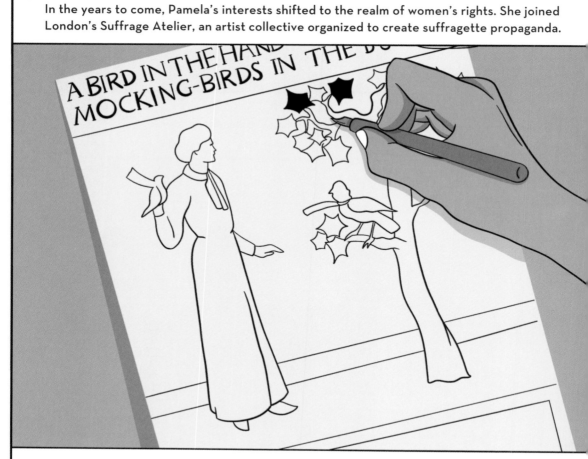

Pamela produced illustrated posters, broadsides, and printed cards to support the movement and used her teaching skills to mentor less-experienced members.

"LEARN FROM EVERYTHING, EVERYTHING, AND ABOVE ALL EVERYTHING, AND MAKE OTHER PEOPLE WHEN THEY LOOK AT your DRAWING FEEL IT TOO!

KEEP AN OPEN MIND TO ALL THINGS, HEAR ALL THE MUSIC YOU CAN, GOOD MUSIC, FOR SOUND AND FORM ARE MORE CLOSELY CONNECTED THAN WE KNOW."

P.C.S.

The following year Pamela was accepted into the Roman Catholic Church after studying intensely for her conversion.

Experimenting with a variety of religions and exploring occult practices throughout her life were significant parts of Pamela's personal growth.

While it may come as a bit of a surprise that Pamela decided to dedicate herself to Catholicism for the remainder of her life, her conversion is indicative of her highly spiritual energy. It's also a sign of a more devout lifestyle that was to come.

Pamela traveled across the sea and had another successful exhibition in New York, again showing synesthesia paintings she created while listening to music.

Pamela had a special and rare gift, synesthesia, a condition in which her sensory pathways crossed and she was able to envision music as colors. Earlier, in 1900, Pamela had her first synesthetic vision while listening to Bach.

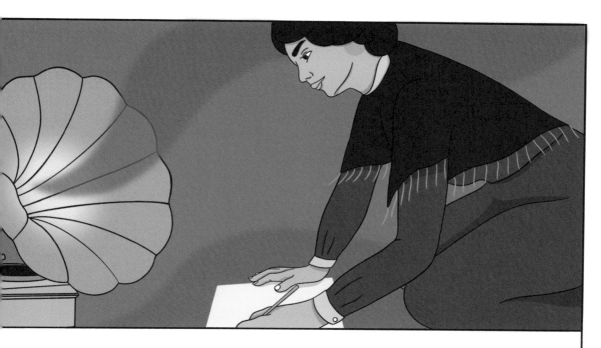

She worked in this way when she created the paintings for this show, leaving viewers in awe. Debussy praised her synesthetic work:

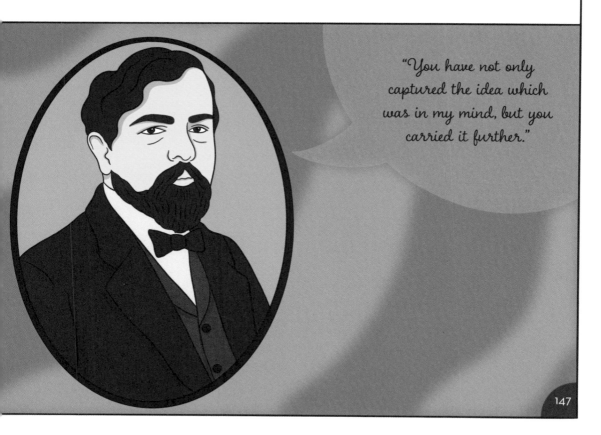

"You have not only captured the idea which was in my mind, but you carried it further."

Pamela stayed busy producing illustrations as well as earning a living as a storyteller at parties for both children and adults.

It's clear that Pamela identified as a performative artist in addition to an illustrator: Her desire to perform extended beyond the practical need for supplemental income.

Her talents transcended visual art and set her apart as a woman of diverse and varied skills—which is remarkable for the time period.

Throughout the next few years, Pamela was productive and continued to broaden her international reach.

She completed several book illustrations including for *The Russian Ballet* written by her friend Ellen Terry, . . .

and was also included in an exhibition as part of the Exposition Universelle et Internationale of 1913 in Ghent, Belgium, and a show at the Louvre in Paris for the British Arts and Crafts Exhibition.

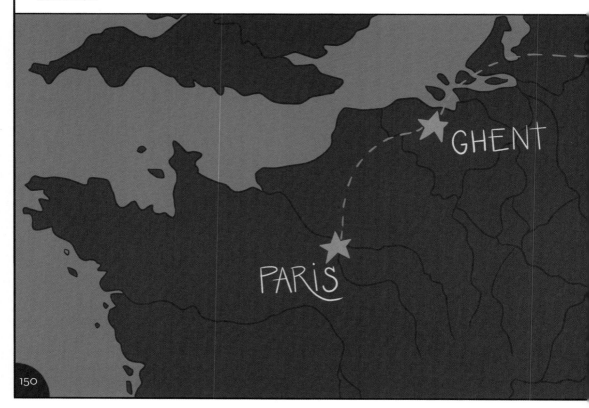

The reason Pamela's fight for women's rights inspires me is because it would have been so much easier for her to just remain complacent.

It's difficult to volunteer your time and work when you're struggling to make ends meet, and Pamela certainly didn't have a carefree daily life.

But despite consistently struggling to have her work recognized, she somehow still found the time to fight.

Pamela stayed a steadfast member of the Suffrage Atelier, never ceasing her fight for women's rights and using her artwork and energy for the cause.

When we look at her life through a modern lens, it makes sense for her to have made such a smooth transition from the occult realm to women's rights.

In current times of injustice, women have also reclaimed the symbol of the witch as a means to fight the patriarchy.

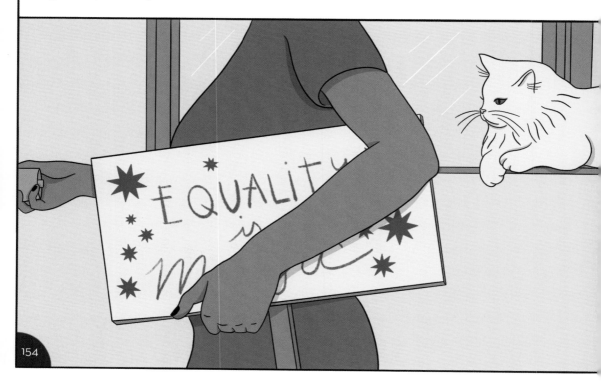

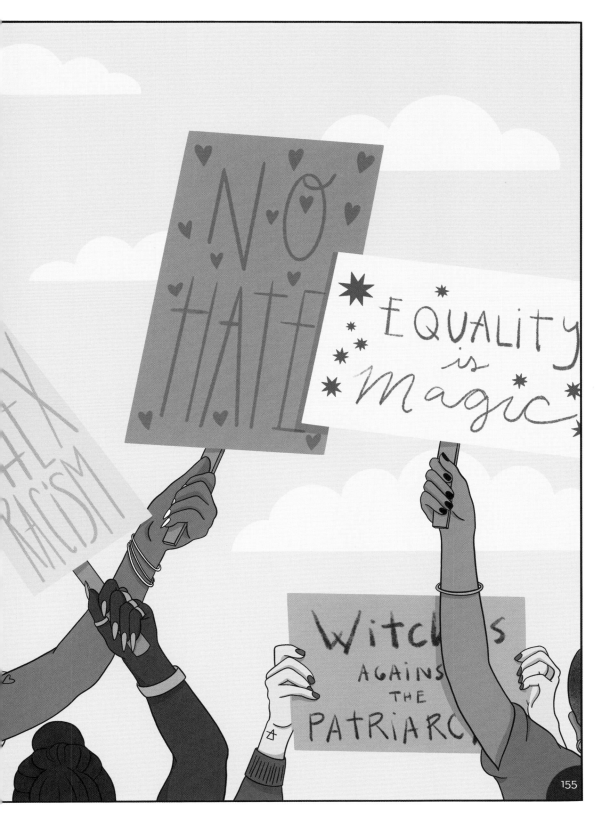

155

And we're now seeing tarot have its largest resurgence since the 1970s as young people work to find meaning in times of oppression.

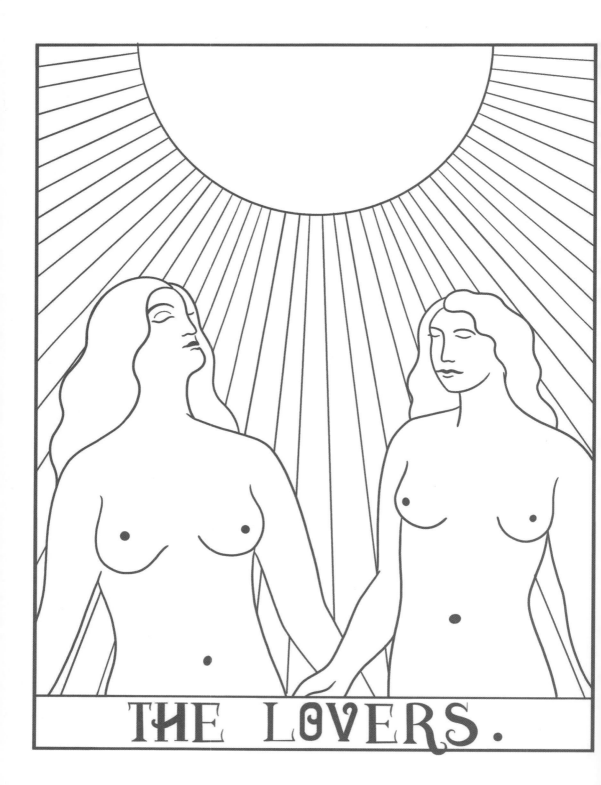

THE LOVERS.

LATER LIFE

VI

1914 — 1951

"I don't care for people anymore."

The 36-year-old Pamela was alone in her apartment, . . .

the live-work space where she had hosted countless gatherings of guests, fostered lively parties, performances, laughter, and fantasy, . . .

and above all, where she had created for 15 years, transcending the expectations of everyone around her.

She cradled a leatherbound volume, . . .

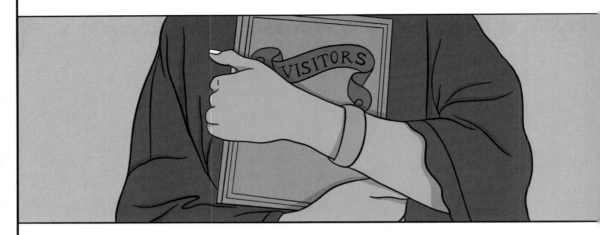

the guest book she had kept in her famous London apartment.

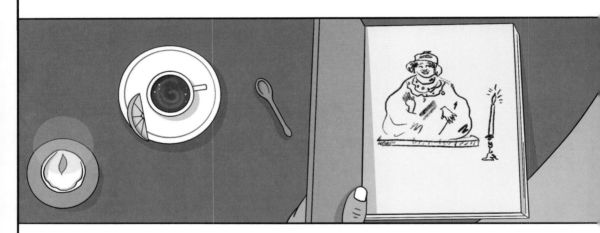

In its 150 pages, she'd enthusiastically documented her visitors and friends throughout the years by collecting their signatures, addresses, stories, letters, and drawings.

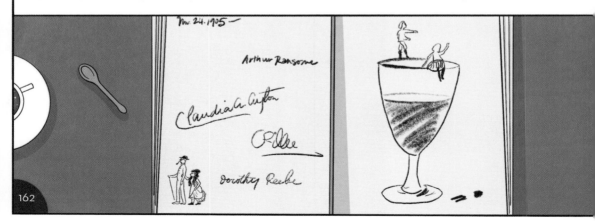

But on this rainy April night, her home was quiet.

No colorful friends were traipsing through the doors, throwing their coats in the foyer with abandon before they rushed in to catch the start of Pamela's latest parlor performance.

No libations flowed, and no songs were sung.

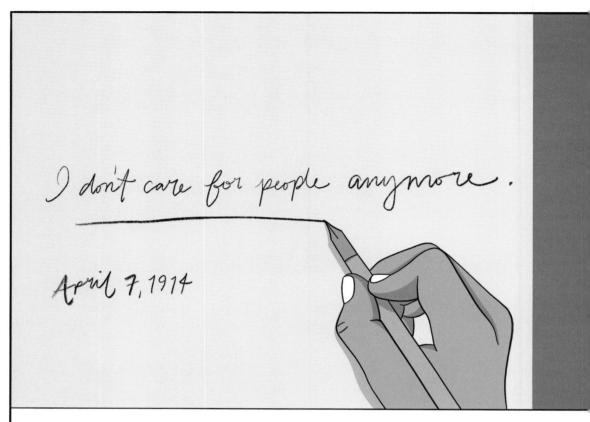

After penning this line, she then closed the book, never to open it again. She gave it to a friend a few days later.

Abandoning the guest book was the start of an emotional shift. The book had served for years as a record of Pamela's social life and her impact on other creative personalities of the time.

In giving the book away, she was choosing to separate herself from that life.

Prior to this year, she had been described as joyful in nature, with a unique sense of humor that was outspoken, and even silly.

But maybe her inability to make a living from her art and her perpetual status as an outsider finally caught up with her carefree personality.

Pamela left her beloved London . . .

and moved to the Lizard Peninsula in West Cornwall.

A full day's journey from London, the Lizard is one of the most isolated locations in England, . . .

surrounded by the sea on three sides.

Pamela's sense of ostracization had begun in childhood, when she and her parents felt alienated as Americans living in Northern England.

And when she was older, Pamela's appearance was described as "exotic," "strange," and even "primitive."

The condescension she endured was a result of Pamela potentially being biracial.

During her lifetime, mixed heritage was uncommon in England and may have informed the public's perception of her, leading to discrimination, being taken advantage of financially, and pandering.

ALONE

ALONE AND IN THE MIDST OF MEN,
ALONE 'MID HILLS AND VALLEYS FAIR;
ALONE UPON A SHIP AT SEA;
ALONE-ALONE, AND EVERYWHERE.

O MANY FOLK I SEE AND KNOW,
SO KIND THEY ARE I SCARCE CAN TELL,
BUT NOW ALONE ON LAND AND SEA,
IN SPITE OF ALL I'M LEFT TO DWELL.

IN CITIES LARGE-IN COUNTRY LANE,
AROUND THE WORLD -'TIS ALL THE SAME;
ACROSS THE SEA FROM SHORE TO SHORE
ALONE-ALONE FOR EVERMORE.

P.C.S

World War I came to England, and with it new demands and challenges for its citizens.

Pamela took a brief break from her period of solitude and volunteered with charitable organizations.

She illustrated posters for groups like the Polish Victims' Relief Fund and the War Refugee Relief Fund and fundraised for the Red Cross.

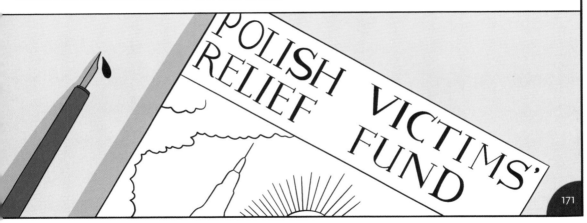

After the war ended, a new chapter began for Pamela, when the death of her uncle left her with a sum of money.

She utilized her new inheritance on property investments, leasing a house called Parc Garland in an artists' colony for herself, . . .

and purchasing a home that she rented out as a seaside retreat for Catholic priests.

Continuing her history of unprofitable businesses, the vacation house was not successful and left Pamela in a precarious financial situation.

However, her home at Parc Garland created space for her companion Nora Lake to reside with her.

Much remains unknown about Pamela's relationship with Nora; however, Nora is said to have been a spiritualist and was likely a lover of Pamela's for many years.

They lived together until Pamela's death, with Pamela acting as somewhat of a caretaker for Nora, who suffered from lingering post-traumatic stress from the war.

Pamela remained steadfast in her efforts to bolster her career, continuing her perusal of book arts and other print illustrations. Even with the challenges she faced, she was recognized by the Royal Society for the Encouragement of Arts, Manufactures, and Commerce with a fellowship in 1941.

In spite of more rejections from publishers, Pamela stayed a prolific creator for the rest of her life, with a burning wealth of creativity and a plethora of ideas to pursue wherever she went.

A cool breeze flowed through Pamela's soft white curls on an otherwise warm September day—a hint of the coming change of season after a bright summer.

With Elsie T. Bates, a friend and housekeeper, at her bedside in Bude, Pamela drew her last breath.

After succumbing to her battle with heart disease, Pamela left this world at the age of 73, taking the last of the images swirling through her imagination with her.

176

She left her estate to Nora Lake as outlined in her will, but after her many debts were accounted for, nothing was left for her companion.

Even her ultimate wish to leave Nora her home couldn't be carried out.

Although her burial is documented in a Catholic cemetery in Bude (Baldhu Parish Churchyard), . . .

her grave remains unmarked and unknown due to her inability to afford a headstone.

There was also a fire, which destroyed death records from this time period, leaving Pamela's vast body of artwork as her only remaining memorial.

At the time of her death, Pamela's work had lost its popularity; however, the Rider-Waite tarot deck has brought her illustrations into the hands of modern admirers, reviving her life's work for millions of people around the globe.

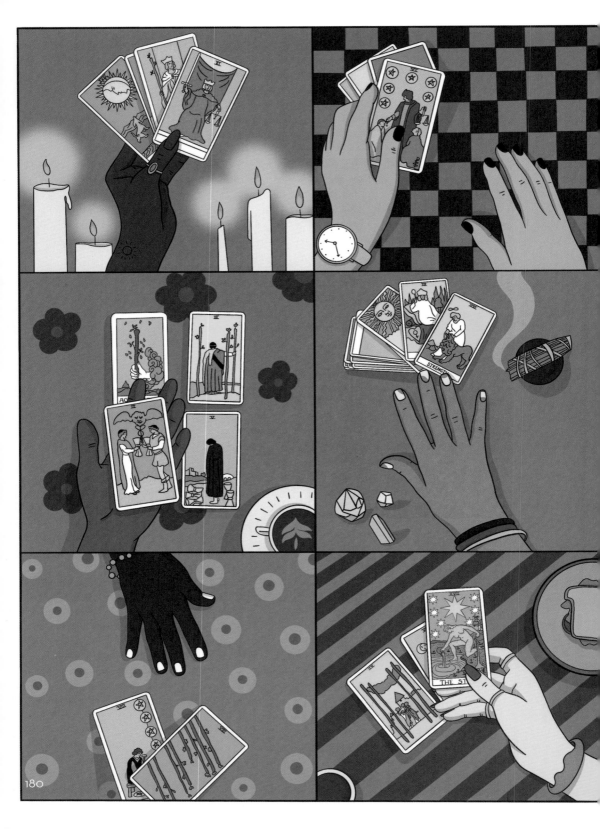

"THINK GOOD THOUGHTS OF BEAUTIFUL THINGS, COLORS, SOUNDS, PLACES, NOT MEAN THOUGHTS. WHEN YOU SEE A LOT OF DIRTY PEOPLE IN A CROWD, DO NOT REMEMBER ONLY THE DIRT, BUT THE GREAT SPIRIT THAT IS IN THEM ALL, AND THE POWER THAT THEY REPRESENT.

"FOR THROUGH UGLINESS BEAUTY IS SOMETIMES FOUND."

P.C.S.

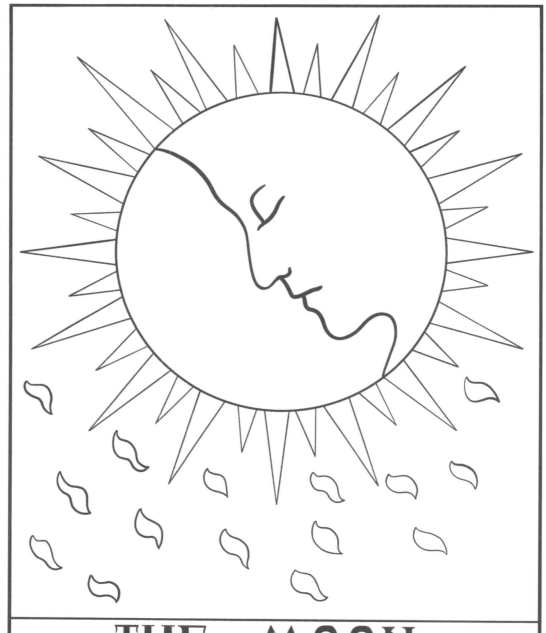

THE MOON.

BEYOND

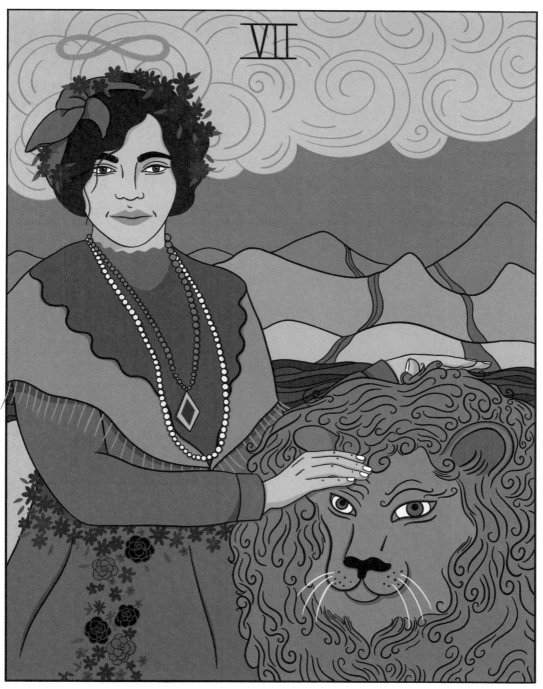

VII

Pamela Colman Smith's death certificate noted that she died a spinster of independent means.

Yet she was so much more than that.

A dreamer, visionary, multitasker, fine artist, illustrator, designer, typographer, actor, performer, author, publisher, daughter, student, mentor, lover, friend, and activist . . .

Pamela's tarot deck and legacy in the realm of the occult have influenced countless artistic successors, and the accessibility of her images has contributed to tarot becoming a mainstream practice with a huge modern resurgence.

By celebrating her work and honoring the challenges she faced during her career, we gain a deeper appreciation for someone who labored tirelessly to create a bit more magic in the world.

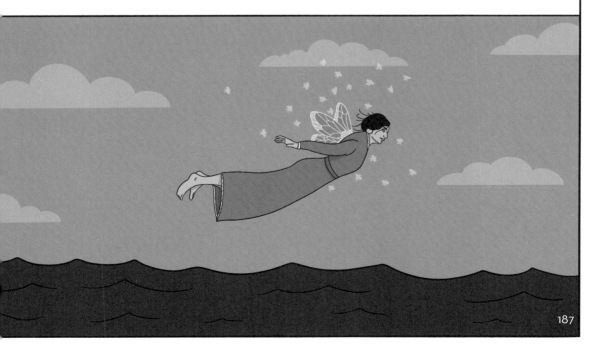

Pamela died in Bude, England, just 15 miles from the village of Tintagel, the enchanted site of Merlin's Cave.

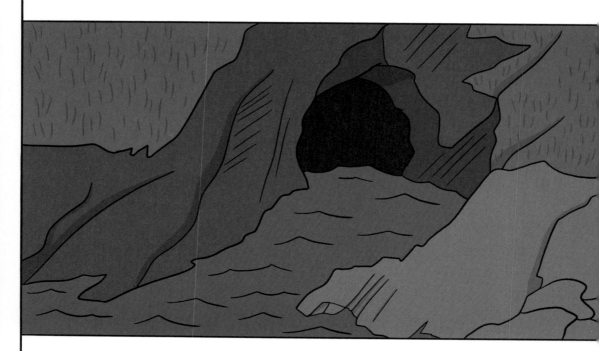

It's said that this cave, under Tintagel Castle, is where Merlin practiced magic and found the infant King Arthur washed ashore.

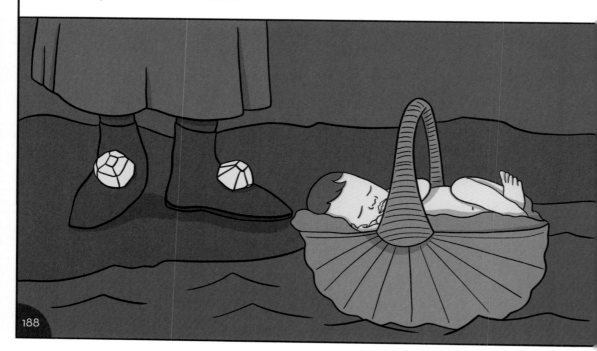

Pamela Colman Smith's life was rich with charm and wonder, and even her death occurred in a place full of magic. I like to imagine that she visited Tintagel and explored Merlin's Cave— carrying a candle through the ancient sea-chiseled tunnel, watching the light flicker in the surf, her own voice echoing behind her as she stepped ever forward.

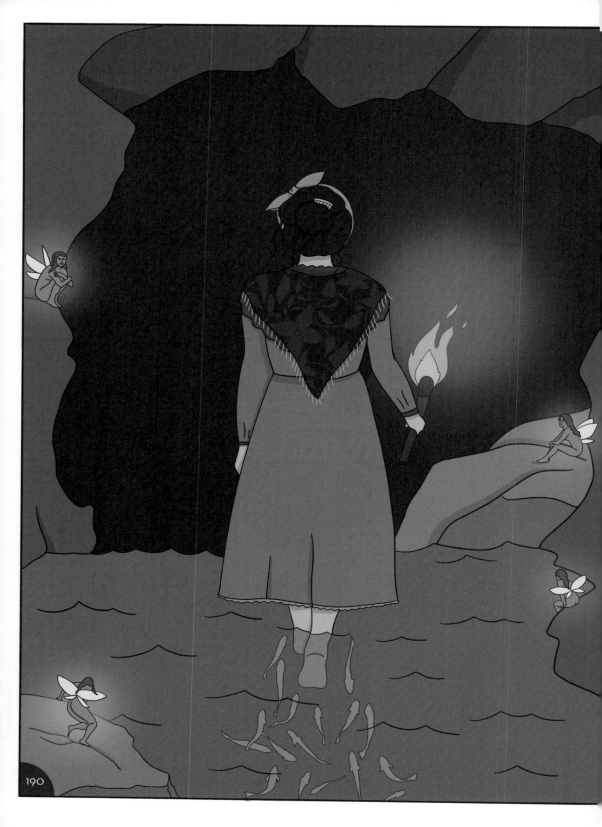

AUTHOR'S NOTE

I have made my best effort to ensure that all the biographical information in this book is as accurate as possible.

Unfortunately, though, Pamela Colman Smith was so under-appreciated and unrecognized in her time, many exact dates or details from her life are unclear or unknown. In those instances, I have done my best to synthesize what is known about her into the likeliest version of events and do her story justice. It is my hope that by elevating Pamela's story and sharing it with more people, we can all begin to more fully understand this remarkable woman and the contributions she made to tarot.

ACKNOWLEDGMENTS

I'd like to acknowledge the extensive research compiled in the book *Pamela Colman Smith: The Untold Story* by Stuart Kaplan, Mary K. Greer, Elizabeth Foley O'Connor, and Melinda Boyd Parsons, which allowed me to accurately tell Pamela's life story.

I want to extend heartfelt thanks to my wonderful agent Joan Brookbank, an unwavering source of support and advocacy.